The
Shot
Doctor

The Amateur's Guide to Taking Great Digital Photos

Mark Edward Soper

que®

800 East 96th Street,
Indianapolis, Indiana 46240 USA

The Shot Doctor:
The Amateur's Guide to Taking Great Digital Photos

ISBN-13: 978-0-7897-3948-3
ISBN-10: 0-7897-3948-8

Library of Congress Cataloging-in-Publication Data:

Soper, Mark Edward.
 The shot doctor : the amateur's guide to taking great digital photos/ Mark Edward Soper.
 p. cm.
 Includes index.
 ISBN 978-0-7897-3948-3
 1. Photography—Digital techniques—Amateurs' manuals.
2. Digital cameras—Amateurs' manuals. I. Title.
 TR267.S653 2009
 771.3'3—dc22

 2009014446
Printed in the United States of America
First Printing: May 2009

Trademarks

Warning and Disclaimer

Bulk Sales

Que Publishing offers excellent discounts on this book when ordered in quantity for bulk purchases or special sales. For more information, please contact

U.S. Corporate and Government Sales
1-800-382-3419
corpsales@pearsontechgroup.com

For sales outside the United States, please contact

International Sales
international@pearson.com

Associate Publisher
Greg Wiegand

Acquisitions Editor
Rick Kughen

Development Editor
Rick Kughen

Managing Editor
Patrick Kanouse

Senior Project Editor
Tonya Simpson

Indexer
Ken Johnson

Proofreader
Dan Knott

Technical Editor
Jay Townsend

Technical Reviewers
Jay Townsend
John Freeland
Matt Thomas

Publishing Coordinator
Cindy Teeters

Book Designer
Anne Jones

Compositor
Mark Shirar

CONTENTS AT A GLANCE

ABOUT THE AUTHOR

Mark Edward Soper has been using adjustable cameras since 1971 and digital cameras since early this decade, for a total of more than 37 years as an enthusiastic and serious amateur photographer. Mr. Soper's when-why-how approach to photography, which combines picture-based methods (take a picture, change settings, see how the picture improves) with just enough photographic theory to help users understand why as well as what to change, has been tested through years of teaching photography to enthusiastic adults and senior adults, as well as by the hundreds of photographs he has taken for many of his books. Mark is the author and co-author of many other technology books, including *Easy Digital Cameras* and *Unleashing Windows Vista Media Center*, as well as books on corporate and home networking, PC upgrades, home automation, and PC troubleshooting.

DEDICATION

For Jondi, who encouraged me to write it. For Rick, who helped make it a reality. For everyone who wants to take better photos.

ACKNOWLEDGMENTS

This book is the result of years of photographic experience but, as always, it's not just my book. Thanks as always to God, who has inspired His ultimate creation, mankind, to fuse science and art into photography.

Thanks also to my family, for their patience when I said, "Just one more shot, please," and for learning (even at a very young age) to ignore the camera so I could get better photos. A special shout-out to the newest members of the family, Jondi, Katie, and Amelia. And to the other photographers in the family: my Grandfather Soper, who gave me my first 35mm camera (an Argus C3); my Grandfather Jayne, who worked for Ansco and was a part-time professional photographer; my dad, who paid for innumerable rolls of film during my high school days and lent me his prized Zeiss-Ikon Contessa; and the younger generation: Ian (for his adventures in extreme low-light photography) and Jeremy (for a great picture of Flower, the cat). And many thanks to Cheryl, who's always been there for me, even back in the darkroom days: much love.

I also want to thank the editorial and design team that Que put together for this book: thanks to Anne, Patrick, Tonya, Ken, Dan,

and Cindy for working together to create a book small enough to carry but big enough to be useful; technical editor Jay Townsend (who also provided some photos and provided review services); technical reviewers John Freeland and Matt Thomas; and Greg Wiegand, for green-lighting the project. Finally, a big thank you to Rick Kughen, for 10 years of working together on book projects. May there be many more!

WE WANT TO HEAR FROM YOU!

As the reader of this book, *you* are our most important critic and commentator. We value your opinion and want to know what we're doing right, what we could do better, what areas you'd like to see us publish in, and any other words of wisdom you're willing to pass our way.

As an associate publisher for Que Publishing, I welcome your comments. You can email or write me directly to let me know what you did or didn't like about this book[md]as well as what we can do to make our books better.

Please note that I cannot help you with technical problems related to the topic of this book. We do have a User Services group, however, where I will forward specific technical questions related to the book.

When you write, please be sure to include this book's title and author as well as your name, email address, and phone number. I will carefully review your comments and share them with the author and editors who worked on the book.

Email: feedback@quepublishing.com

Mail: Greg Wiegand
Associate Publisher
Que Publishing
800 East 96th Street
Indianapolis, IN 46240 USA

READER SERVICES

Visit our website and register this book at informit.com/register for convenient access to any updates, downloads, or errata that might be available for this book.

INTRODUCTION

A BETTER BOOK FOR EVERYDAY PHOTOGRAPHY

Lots of photography books include beautiful photos of exotic locations and scenery. Not this one. I hope you'll enjoy the photos, of course, but I also hope you'll see that the photos included in this book are similar to the ones you've been taking—or would like to take. Graduations, babies, weddings, vacations...the list of photography possibilities goes on—and so do the frustrations.

If you have a digital camera and you're frustrated with your photos, you've opened the right book—I wrote it just for you. Whether you have a modest digital point-and-shoot camera or have laid out the big bucks for a digital SLR with interchangeable lenses (DSLR), you've been taking photos of the most important events in your life—and you've probably been disappointed by the results.

Believe me, I understand. This book was conceived as a result of conversations I had with friends and family who'd gotten new cameras, taken them to special events, and been frustrated by the poor-quality photos they'd taken. I want to help you stop being frustrated with your camera and start enjoying it.

This book is the end result of more than 35 years as a photographer and more than 6 years as a digital camera user. During that time, I've developed a series of recipes I use in different situations to help ensure better photos. And while I prefer to do most of my "serious" shooting with a Canon Digital Rebel XTi DSLR camera, the majority of the photos in this book were shot with various point-and-shoot cameras made by Canon, Nikon, and Kodak; the same types of cameras you use for family, everyday, and vacation photos. In most cases, I provide methods that can be used either with scene-driven cameras or cameras with traditional aperture, shutter, and manual exposure control.

To get the most out of this book, I suggest the following:

- **Read your camera's manual**—This book will tell you how and why to use particular features, but your camera manual provides the nitty-gritty details. I recommend carrying both this book and your camera manual with you.

- **Shoot, look, evaluate, and change settings**—Digital cameras make seeing your work easy: Photos show up on the LCD display as soon as you take a picture, and you can play back your photos anytime you want. If you've been accustomed to taking a bunch of photos and then reviewing them, it's time for a change. Take a photo or two, look over the pictures, and if you're not satisfied, use the appropriate parts of the book for suggestions. Make those changes and reshoot. I think you'll see a big difference.

QUICK REFERENCE TO COMMON PHOTO PROBLEMS

Problem	Causes	Solution	References
Focusing and Image Blur Problems			
The subject is blurred; other parts of the photo are sharp	The camera focused on the wrong area of the picture	Use focus/exposure lock to lock the subject in sharp focus	Page 170
Can't focus on the subject due to obstructions (wires, bars, screens, and so on)	The camera autofocuses on the object closest to the lens	Use focus lock to focus on an object at a similar distance; change the focus point; use manual focus	Pages 170, 172, 177
The camera focuses on the wrong part of the scene (the subject is blurry)	The camera has multiple focus points, which might not match what you want to focus on	Switch the camera to use only a single focus point	Page 172
The camera is not focusing on people in the photo	Face detection is not enabled	Enable face detection	Page 171
Can't focus on rapidly moving objects	Normal focus mode locks focus and exposure	Switch to Servo autofocus or Sports mode	Page 171
The entire photo is blurred and streaky	The shutter speed is too slow for hand-held shooting	Use a tripod, or switch to a faster shutter speed and increase ISO as needed	Page 141
The subject is blurred and streaky	The shutter speed is too slow to stop action	Switch to S/Tv mode and increase the shutter speed or use Sports mode; increase ISO as needed; wait for the peak of action to shoot	Page 143

Problem	Causes	Solution	References
Part of the photo is out of focus	The depth of field is not deep enough to get everything in focus	Switch to A/Av mode and use f/11 or narrower aperture or use Landscape mode; increase ISO or use a tripod to avoid camera shake	Page 174
Distracting background and subject are both in focus	Depth of field is too deep	Switch to A/Av mode and use f/1.8–f/5.6 aperture or use Portrait mode; focus on the subject; decrease ISO if needed	Page 174

Color Problems

Problem	Causes	Solution	References
Indoor nonflash photo is too yellow, orange, or blue	The white balance is incorrect	Use incandescent or tungsten WB with traditional bulbs; fluorescent WB with tube fluorescent or CFLs	Pages 131, 133, 134
Indoor flash photo is too blue	The white balance is incorrect	Use Auto, Daylight, or Flash WB when using flash	Page 131
Outside sunny day photo is too blue	The white balance is incorrect	Use Auto or Daylight WB	Page 131
Outside cloudy day photo is too blue	The white balance is incorrect	Use Cloudy or Open Shade WB	Pages 131, 135
Can't find a satisfactory white balance	Preset white balance settings don't always provide a satisfactory match for lighting conditions	Use custom (preset) white balance; shoot in RAW mode and correct later	Pages 113, 131, 137
Outside sunny day photo has reflections on leaves, water, or glass	Nonpolarized light causes glare	Attach a polarizing filter and adjust the reflection level by turning the front element of the filter	Page 192
Can't select WB settings	The camera is set for full auto mode	Select P, A/Av, S/Tv, or M modes	Chapter 9, "Introduction to Creative Control Modes"
Pictures are in black and white	The camera is set to a monochrome or black-and-white color setting	Change the color setting to normal or neutral	Page 138

Problem	Causes	Solution	References

Exposure Problems

Problem	Causes	Solution	References
Outdoor daytime photo is too light (overexposed)	Incorrect camera settings	Reduce ISO to the next lower setting; use faster shutter speed or narrower aperture; set EV adjustment to -1.	Pages 101, 103, 106, 118, 122
The subject is too light (overexposed) but the background is properly exposed	The camera is setting exposure based on the background	Use an EV adjustment of -1, reshoot, and adjust EV settings as needed	Page 118
Outdoor daytime photo is too dark (underexposed)	Incorrect camera settings	Use a slower shutter speed or wider aperture; set EV adjustment to +1; increase ISO to the next step	Pages 101, 103, 106, 118, 122
The subject is too dark (underexposed) but the background is properly exposed	The camera is setting the exposure based on the background	Use an EV adjustment of +1; reshoot, and adjust EV settings as needed	Page 118
The camera can't set the proper exposure regardless of EV adjustment	Extreme bright or dark areas in the photo can throw off exposure	Note the shutter speed and aperture selected by the camera; set the camera to Manual (M) mode and set aperture and shutter speed manually; use ISO 400 or higher in dim light	Pages 106, 122
Flash picture is too bright	The camera might be focused past the subject or be using too high an ISO, or you might be too close to the subject	Make sure you're not too close to the subject; use focus lock to focus on the nearest part of the subject; reduce ISO to 400 or less; use Flash EV adjustment of -0.7 to -1.	Pages 122, 164, 170

Problem	Causes	Solution	References
Flash picture is too dark	The subject is beyond the flash range; flash might be partially blocked; flash exposure compensation might be enabled; too low an ISO	Make sure you're not blocking the flash with your hand; increase ISO to 400 or higher; make sure flash exposure compensation is set to 0 or higher; move closer to the subject; zoom back to permit wider aperture; turn off flash and shoot using available light	Pages 47, 122, 164, 186
I don't know what exposure I used for my photos	The camera stores this information as metadata inside the image files, but most cameras do not display this information when you review photos unless you change viewing options	Press the Information or Display button while reviewing your photos to see exposure metadata	Page 108

Lens Problems

Problem	Causes	Solution	References
Shots with minimal zoom are exposed properly but are too dark when zooming in	The zoom lens has a variable aperture and lets in less light as you zoom closer	Increase the ISO setting; in A/Av mode, choose an aperture that is available in any zoom setting	Pages 103, 122, 186
Photos taken at the widest zoom setting (1x) have bowed lines	Zoom lenses often have distortion problems at both ends of the zoom range	Zoom to 2x or 3x; correct the distortion with a photo editor after shooting	Page 187
When I shoot tall buildings, they seem to be toppling backward	This is normal when you shoot tall buildings from ground level	Take photos of tall buildings from the upper floor of another building; correct distortion in a photo editor after shooting	Page 83

Problem	Causes	Solution	References
There are two colored dots on the lens mount for my DSLR and I don't know which one to use for my lenses	This method of marking is used on cameras that can use film camera lenses or lenses made especially for DSLRs	Look at the colored dot on your lens and line it up with the appropriate dot on your camera	—
I'm seeing colored blotches when I point my camera toward the sun	These are reflections off the lens elements and are normal	Use a lens hood, or use your hand to block direct sunlight from shining into the lens	—
When I use a polarizer lens filter, different parts of the sky are different shades of blue	This happens when you use polarizers on a wide-angle zoom	The polarizer works best at a 90° angle to direct sun; adjust the filter	—

QUICK TOUR OF TYPICAL DIGITAL CAMERAS

Use this chapter to get up to speed on the controls and control locations used on digital point-and-shoot and DSLR cameras. Although you might use a camera that differs in some ways from these cameras, many cameras from different vendors use the same or similar controls and markings.

TIP Blue markings on camera controls are used to indicate functions when viewing (playing back) photos.

NIKON COOLPIX L3

The Coolpix L3, shown in Figures 2.1 and 2.2, is a typical example of a low-end pocket-sized digital point-and-shoot camera. It includes a 3x zoom and a large number of scene settings.

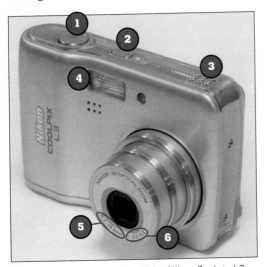

1. Shutter Button

2. On/Off Switch

3. Microphone

4. Electronic Flash

5. Zoom Specifications

6. Maximum Aperture Range

Figure 2.1—*The front view of the Nikon Coolpix L3.*

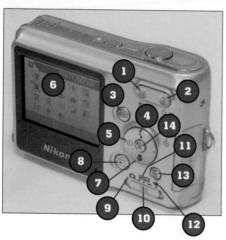

1. Wide-angle Zoom Control
2. Telephoto Zoom Control
3. Toggles Menu On/Off
4. Electronic Flash Control
5. Self-timer
6. Scene Menu
7. Macro (Close-up)
8. Picture Viewing/Playback
9. Auto Mode
10. Shooting Mode Selector
11. Scene Mode
12. Movie (Video) Mode
13. Picture/Video Delete
14. Selects Current Menu
 Setting

Figure 2.2—*The rear view of the Nikon Coolpix L3.*

CANON POWERSHOT A580

The Canon PowerShot A580, shown in Figures 2.3 and 2.4, is a typical example of a digital point-and-shoot camera with some creative control (use the M "Manual" mode) as well as several scene settings. Some scene settings are selected with the control dial, while others are available through a menu.

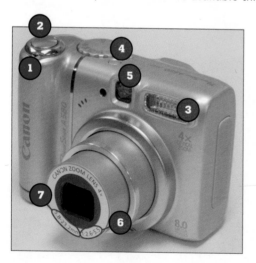

1. Zoom Control

2. Shutter Button

3. Electronic Flash

4. On/Off Switch

5. Optical Viewfinder

6. Maximum Aperture Ran

7. Zoom Specifications

Figure 2.3—*The front view of the Canon PowerShot A580.*

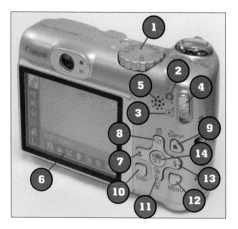

1. Control Dial
2. Shooting Mode
3. Playback Mode
4. Mode Selector
5. Microphone
6. Scene Menu
7. Macro (Close-up)
8. Selects ISO
9. Selects Photo for Printing
10. Toggles Live View On/Off; Displays Exposure Information
11. Normal, Burst, Self-timer; Deletes Photos
12. Toggles Menu On/Off
13. Electronic Flash Control
14. Selects Current Menu Setting

Figure 2.4—*The rear view of the Canon PowerShot A580.*

KODAK ZD8612

The Kodak ZD8612, shown in Figures 2.5 and 2.6, is a typical example of a digital point-and-shoot camera with long (12x) zoom, full creative control (Program, Aperture Priority, Shutter Priority, and Manual) as well as several scene settings. Some scene settings are selected with the control dial, while others are available through a menu.

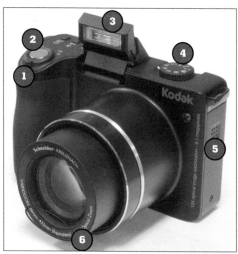

1. Zoom Control
2. Shutter Button
3. Pop-up Electronic Flash
4. Control Dial
5. Microphone
6. Zoom Lens Specifications

Figure 2.5—*The front view of the Kodak ZD8612.*

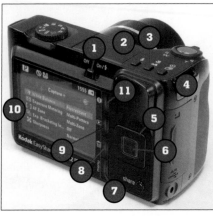

1. On/Off/Flash ON Switch
2. Flash Control
3. Macro/Distant/Normal Focus
4. Burst/Self-timer
5. Four-way Scroll
6. Selects Setting
7. Toggles Menu On/Off
8. Deletes Photos in Playback Mode
9. Playback
10. Advanced Capture Menu
11. Displays Exposure Information

Figure 2.6—*The rear view of the Kodak ZD8612.*

CANON DIGITAL REBEL XTI/EOS 400D

The Canon Digital Rebel XTi, shown in Figures 2.7 and 2.8, is known as the EOS 400D in some markets. It's a typical example of a consumer-level DSLR. It offers a wide variety of creative control modes as well as scene modes, and it can be equipped with EF and EF-S compatible lenses from Canon and other vendors. It also can be equipped with EOS digital-compatible electronic flash units from Canon and other vendors.

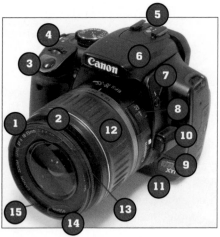

1. Zoom Lens Specifications
2. Maximum Aperture Range (Partly Obscured)
3. Shutter Button
4. Control Wheel
5. Hot Shoe for Electronic Flash
6. Pop-up Electronic Flash
7. Flash Control
8. Auto/Manual Focus Selector
9. EF-S Lens Alignment Dot
10. Lens Release
11. Depth-of-Field Preview
12. Zoom Control Ring
13. Focusing Ring
14. Filter Size
15. Screw Threads for Attaching Filter

Figure 2.7—*The front view of the Canon Digital Rebel XTi.*

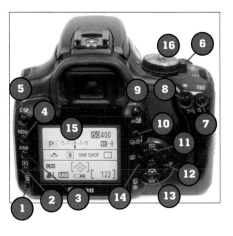

1. Deletes Photos in Playback Mode
2. Playback
3. Jump Button (Playback Mode)
4. Toggles LCD Menu On/Off
5. Displays Current Camera Settings; Exposure Information (Playback Mode)
6. On/Off Control
7. Select Autofocus (AF) Points
8. Auto/Flash Exposure Lock
9. AV/EV Compensation
10. Burst/Self-timer/Remote
11. ISO Selection
12. Autofocus (AF) Selection
13. White Balance (WB) Selection
14. Metering Method Selection
15. Shooting Menu
16. Shooting Mode Control Dial

Figure 2.8—*The rear view of the Canon Digital Rebel XTi.*

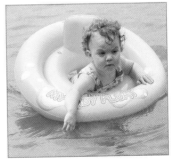

TOP TEN PROBLEM PHOTO SITUATIONS— AND HOW TO GET BETTER PHOTOS

Using digital photography is one of the most popular ways to capture the special moments in the lives of family and friends. This top ten list includes some of the most important events you'll want to remember, as well as some of the trickiest technical situations you might encounter. Use it to get a jump on solving your hardest photo problems.

SNOW/BEACH/WATER

Because digital cameras assume that typical scenes contain a wide range of light to dark tones, scenes with a brighter-than-usual background, such as snow, beach, and water, can play havoc with your camera's light metering system. To avoid getting dark and gloomy photos as shown in Figure 3.1, use your camera's snow or beach scene modes as appropriate, or increase exposure by about +0.7–1.0 EV. The results can be seen in Figure 3.2.

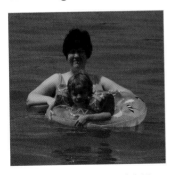

Figure 3.1—Ironically, a bright background (such as water or snow) can lead to dull, underexposed photos.

Figure 3.2—Using the beach scene mode or +1 EV adjustment (shown here) keeps the main subject from being lost in the dark.

→ Learn more about scene modes in **Chapter 5**, "Using Scenes."

→ Learn more about EV adjustment (also known as exposure adjustment or exposure bias) in **Chapter 10**, "Improving Exposure."

GRADUATION

Whether it's a preschooler heading off to kindergarten, a nontraditional student retooling for the future, or anybody at any age, graduation is one of the most important rites of passage you can photograph. To avoid poor-quality photos of the procession down the aisle, make sure you grab the prime aisle seating; otherwise, you might end up with a flash photo that's barely salvageable even with a photo editor (see Figure 3.3).

Figure 3.3—The graduate was too far away for the onboard flash to reach (left). A trip through Adobe Photoshop improved the photo, but at the cost of a lot of digital noise (right).

To avoid problems with electronic flash, try shooting the procession without a flash if there's enough light, or if you have a high enough usable ISO setting (see Figure 3.4).

→ Learn more about using your camera's electronic flash in **Chapter 13**, "Using Electronic Flash."

→ Learn more about ISO settings in **Chapter 10**, "Improving Exposure."

→ Learn more about selecting white balance settings in **Chapter 11**, "Improving Color."

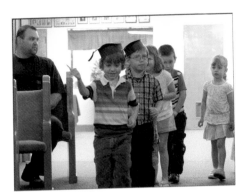

Figure 3.4—No flash, high ISO, and incandescent/tungsten white balance makes for an enjoyable character study of a preschool graduation procession.

BIRTHDAY CANDLES

The magic of birthday candles just doesn't come through when you shoot a flash photo. In fact, with a front angle like this, it can even look scary, as shown in Figure 3.5! Use scene modes such as Candlelight and Hi ISO, or select incandescent lighting and a high ISO, along with a different angle, to capture the magic (see Figure 3.6).

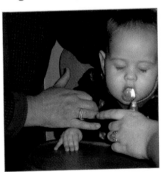

Figure 3.5—The wrong angle and electronic flash lighting take the magic out of this first birthday candle.

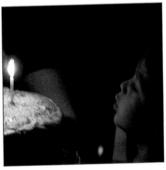

Figure 3.6—To capture the magic of the event, let the candles provide the light.

→ Learn more about selecting scene modes in **Chapter 5**, "Using Scenes."

→ Learn more about ISO settings in **Chapter 10**, "Improving Exposure."

→ Learn more about selecting white balance settings in **Chapter 11**, "Improving Color."

SPARKLERS AND CELEBRATIONS

Sparklers are a lot of fun, whether they're used at the 4th of July or as the bride and groom leave the wedding. Because sparklers are used in dim light, though, your digital camera might have a hard time focusing on the action (see Figure 3.7). Give your camera time to focus, and if you're shooting sparklers in dim light, use a tripod or another firm support so the sparkler can provide the light (see Figure 3.8). Use the Fireworks scene mode or a long shutter speed setting to get pictures like Figure 3.8.

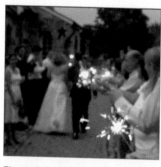

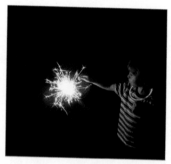

Figure 3.7—*Some digital cameras will take photos even if there's nothing in focus.*

Figure 3.8—*I asked the subject for a little cooperation in holding the sparkler still for a 1-second exposure, and the result speaks for itself.*

→ Learn more about selecting scene modes in **Chapter 5**, "Using Scenes."

→ Learn more about selecting shutter speeds in **Chapter 9**, "Introduction to Creative Control Modes," and **Chapter 12**, "Stopping Action."

CONCERTS AND STAGE SHOWS

Whether it's a favorite rock band or your child on stage, stage lighting can make getting the pictures you want a challenge. You're usually too far away to use a flash, and if you don't set your camera correctly, you might wind up with an off-color, blurry shot like the one in Figure 3.9.

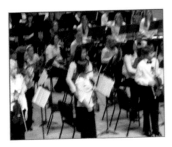

Figure 3.9—*Normal camera settings with the flash turned off can't get the stage color right or prevent camera shake in a typical theater.*

Figure 3.10—*Increasing the ISO to 400 or more, reducing the exposure a bit, and adjusting the white balance to incandescent/tungsten are the keys to better concert and stage photography.*

CHILDREN AT PLAY AND IN GROUPS

Whether you see children at play on a daily basis or they're a rare treat (such as when the grandchildren visit), catching them "in the act" is tough, indoors or out. They're good at zigzagging away from you and your camera, giving you shots like Figure 3.11. To outsmart them, figure out where they'll be playing and prefocus on the top of the ladder, the bottom of the slide, or the exit from the play tubes (see Figure 3.12).

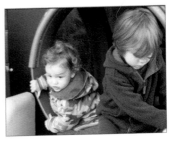

Figure 3.11—*Many digital cameras don't focus or zoom fast enough to handle a last-minute course change by your favorite bundle of energy.*

Figure 3.12—*By prefocusing on where children will be as they play, you can get better photos.*

→ *Learn more about using Focus Lock to prefocus in* **Chapter 14**, *"Controlling What's in Focus."*

Group photos are a staple of family reunions, birthdays, and weddings. Getting adults to look in the same direction and look pleasant can be tough enough, but if the subject is children, be prepared to be very patient and take a lot of pictures, especially if you're not using a flash (see Figure 3.13). Persistence pays off, especially if you have a helper to keep the kids entertained (see Figure 3.14).

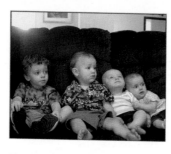

Figure 3.13—*Somebody didn't get the memo about not looking at the ceiling—and somebody else looks worried.*

Figure 3.14—*Success at last— their personalities come through.*

→ *Learn more about handling indoor lighting in **Chapter 11**, "Improving Color."*

SIDELIGHTING AND BACKLIGHTING

Digital cameras are good at handling exposures when the sun's over your shoulder, but sidelit or backlit photos are generally more interesting. If you're shooting against a bright background, though, your camera will probably underexpose the subject (see Figure 3.15). You can increase exposure by using EV adjustment of +1.0 to +2.0, but for subjects less than 10 feet away, you can get better results with fill flash, especially if your camera has a flash EV adjustment (try -0.7 to -1.3 EV), as in Figure 3.16.

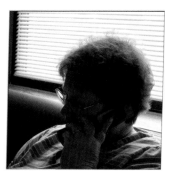

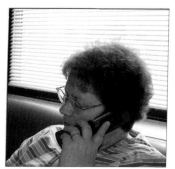

Figure 3.15—*The strong light behind the subject fools the camera, so the subject is underexposed.*

Figure 3.16—*By using fill flash, the subject is now properly exposed.*

→ *Learn more about using EV (exposure compensation) adjustments in **Chapter 10**, "Improving Exposure," and in **Chapter 13**, "Using Electronic Flash."*

WEDDING DAY

Whether you're a friend of the bride, a friend of the groom, or just along for the day, the bride and groom are the most important subjects of wedding day photos. Even if you're not sitting where you can get the classic processional photos, there are plenty of opportunities at the reception. However, receptions are notorious for crowded backgrounds and foregrounds as in Figure 3.17. The solution? Wait for the crowds to thin out (even if they don't completely disappear) and you can get better photos of the happy couple (see Figure 3.18).

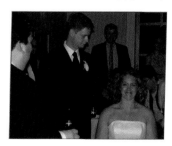

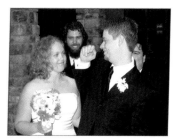

Figure 3.17—*It can be hard to find the bride and groom in a photo where they're surrounded by well-wishers.*

Figure 3.18—*This time, the well-wishers are part of a simpler background, so the attention is on the newlyweds.*

→ *Learn more about better flash photography in* **Chapter 13**, *"Using Electronic Flash."*

NEW BABY

Most events can't be repeated exactly— and that goes double for the birth and growth of a baby. While it's wonderful that everyone wants to hold the new baby, make sure you keep in mind that the new baby's the most important subject. Cameras use the focusing distance to set flash exposure, and Figure 3.19 shows what happens if you focus on the background instead of the baby. Zooming in on the baby, though, can help you get sharp focus and good flash exposure to record every detail of your precious newborn (see Figure 3.20).

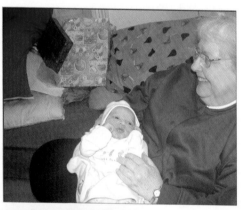

Figure 3.19—*The baby's covered up, but thanks to focusing on the background, the baby and great grandma are also overexposed.*

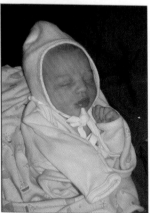

Figure 3.20—*A simpler shot that zooms in on the baby captures his tiny features.*

→ Learn more about using Focus Lock in **Chapter 14**, "Controlling What's in Focus."

→ Learn more about better flash photography in **Chapter 13**, "Using Electronic Flash."

SPORTS

Low-cost digital cameras with limited zoom range (6x or smaller) have a hard time coping with fast-moving sports such as soccer, football, or basketball. The key is to wait for the action to come to you. Keep in mind, though, that the typical Auto setting on a digital camera won't provide fast enough shutter speeds to stop action (see Figure 3.21). For better photos, switch the camera to a mode in which you can select a higher ISO and a faster shutter speed (see Figure 3.22). On some cameras, Sports mode can be used to provide similar benefits.

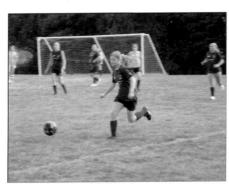

Figure 3.21—This camera's Auto mode selected ISO 160 and a low shutter speed, ruining the photo with excessive motion blur.

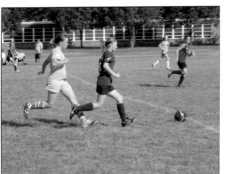

Figure 3.22—Same camera, same 4x zoom, but this time selecting ISO 400 allowed a fast enough shutter speed to record the action.

→ *Learn more about selecting scene modes in **Chapter 5**, "Using Scenes."*

→ *Learn more about selecting shutter speeds in **Chapter 9**, "Introduction to Creative Control Modes," and **Chapter 12**, "Stopping Action."*

→ *Learn more about ISO settings in **Chapter 10**, "Improving Exposure."*

WHAT YOU CAN (AND CANNOT) DO IN AUTO MODE

SELECTING AUTO MODE

Auto mode makes taking pictures point-and-click simple. If it's daylight, if the light's falling on the front or side of your subject, or if you're using a flash within 10 feet of your subject, you can use Auto mode to get very nice photos.

To select Auto mode on most cameras:

1. Turn on the camera.
2. Turn the selector dial on top of the camera to the Auto selection. Many cameras mark this setting with a green label or a green icon (see Figure 4.1).
3. Point and shoot.

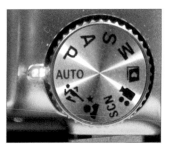

Figure 4.1—*Selecting Auto mode on typical cameras.*

WHAT AUTO MODE DOES

Here's what you can control in Auto mode:

- Where you point the camera
- When to take the picture

That's it! The camera takes care of everything else. So, what assumptions does the camera make? Typical Auto mode settings include

- **Auto white balance**—The camera attempts to select a setting that produces accurate colors.

- **Auto ISO**—The camera adjusts the ISO between a range of ISO 64–80 on the low side to 200–320 on the high side (it varies by camera). These ISO settings are appropriate for bright or hazy sunshine or electronic flash. In fact, Auto mode fires the flash if it determines there's not enough light for a hand-holdable shot.

- **Shutter speed and aperture**—These values are selected to enable the average user to get sharp hand-held shots. When the flash is fired, the camera uses the largest available aperture for the best possible exposure in limited light.

Unfortunately, the settings used by Auto mode aren't always the best ones for every photo. In the next sections, you'll see the kinds of photos Auto mode does well, as well as the kinds of pictures where Auto mode just isn't the best choice.

 NOTE Some cameras offer both Auto and Simple modes. On cameras with both modes, the Simple mode prevents you from overriding any settings, while the Auto mode provides a few settings you can change. You might be able to switch between Auto and Hi ISO settings or select color modes, for example.

WHEN AUTO MODE SHINES

Auto mode does a great job on typical sunny days like the ones in Figures 4.2 and 4.3.

Even if the background is much lighter than the foreground, you can use Focus and Exposure Lock to make sure you get the subject exposed just right (see Figure 4.4).

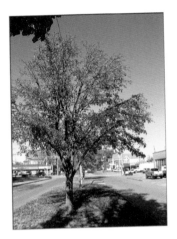

Figure 4.2—Auto mode produces great results with front-lit subjects like this colorful tree...

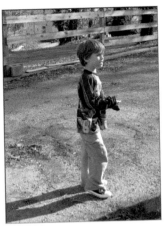

Figure 4.3—...and with side-lit subjects like this boy in play.

Figure 4.4—Focus and Exposure Lock enable you to shoot better photos of off-center subjects or subjects with light or dark backgrounds, even if you can't override the camera's normal exposure settings.

→ To learn more about using Exposure Lock, see **Chapter 10**, "Improving Exposure." To learn more about Focus Lock, see **Chapter 14**, "Controlling What's in Focus."

Auto mode also works with indoor subjects just a few feet from the camera, as it automatically uses your camera's electronic flash (see Figure 4.5).

Figure 4.5—
Subjects less than 10 feet away are well lit by the onboard flash when you use Auto mode.

WHEN AUTO MODE HAS PROBLEMS

Unfortunately, Auto mode has problems with night scenes (Figure 4.6), fast action (Figure 4.7), snowy days (Figure 4.8), and cloudy days (Figure 4.9), to name just a few less-than-perfect situations.

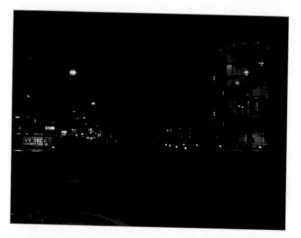

Figure 4.6—*Auto mode fires the flash, but a slow shutter speed (and a tripod) are what are really needed to see the beauty of this building.*

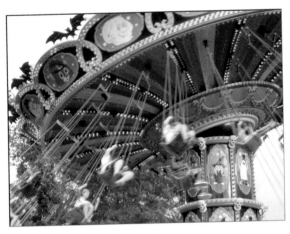

Figure 4.7—*This amusement park ride is spinning too fast for Auto mode.*

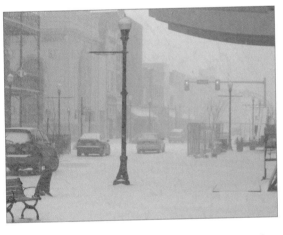

Figure 4.8—*Auto mode renders the beauty of the snowstorm as dull gray.*

1. Auto Mode (No Flash)
1/5 Second Exposure

2. Auto Mode (with Flash)
1/60 Second Exposure

Figure 4.9—*Using flash can "burn out" (overexpose) people who are too close to the camera (right), but if you turn off the flash in Auto mode, you might have problems with subject blur on cloudy days (left).*

EVALUATING YOUR PHOTOS

One of the great advantages of digital photography is the capability to see your photos as soon as you take them. Digital cameras automatically display your photo for a few moments after it is taken. Afterward, use the Playback or Review button on the back of your camera to display your photos. Use the two-way or four-way control pad on the back of your camera to scroll through your photos.

GOING BEYOND AUTO MODE

When Auto mode doesn't do the job, what next? Depending on your camera, you can use one or both of the following methods to get better photos under a wider range of conditions:

- **Scene modes**—Scene modes provide special combinations of settings for a variety of situations. They can be selected from the control dial on some cameras, the shooting menu, or sometimes in both places. See Chapter 5, "Using Scenes," for details.

- **Advanced exposure options**—Select your own settings or help the camera choose better settings. See Chapter 9 to get started.

USING SCENES

UNDERSTANDING SCENES

Most digital cameras, whether they're simple point-and-shoot models or sophisticated digital SLR models, include several scene settings. These can be selected from a dial (see Figure 5.1) or from a menu (see Figure 5.2).

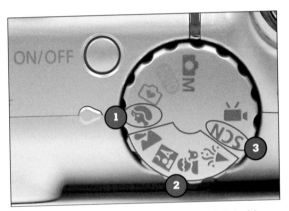

1. Selected Scene

2. Other Scenes

3. Opens Scene Menu

Figure 5.1—*A typical digital camera's control dial with the Portrait scene selected.*

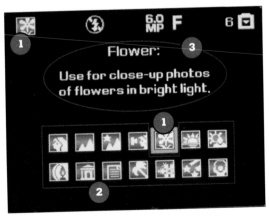

1. Selected Scene

2. Other Scenes

3. Description of Selected Scene

Figure 5.2—*A typical digital camera's scene menu.*

So what are scenes, and what can they do for your pictures? Scene settings provide an easy way to override your camera's normal settings so you get better pictures in particular situations. As the examples in this chapter demonstrate, using scene settings can help you get better photos without needing to learn a lot about technical details.

TYPES OF SCENE SETTINGS

Scene settings vary by camera, but typical examples include

- Better photos in extreme lighting conditions, such as snow or beach scenes

- Better photos in low-light situations, such as fireworks, candlelight, or night photography

- Correcting color (white balance) problems, such as those caused by aquariums, candlelight, or museum lighting

- Better photos of fast action or portraits

- Disabling features that could be distracting in public places, such as flash or audio cues

HOW TO USE SCENES

As you saw in Figures 5.1 and 5.2, there are two ways to select scenes:

- To use a scene setting on the camera's control dial, select the appropriate scene icon and shoot your photos.

- To use a scene setting from a menu, open the Scene menu (see your camera manual for details) and choose the appropriate scene setting from the menu.

Many newer cameras offer a variety of different scene settings, but camera manuals don't always do a good job of explaining— or showing—the difference between the photo you'd get in Auto mode and the photo you'd get by selecting the appropriate scene setting. In the following pages, we'll demonstrate some typical scenes, and I encourage you to perform similar tests with your camera. Here's how to do it:

1. Set your camera to Auto mode and take the picture.

2. Select the scene option that most closely resembles the shooting situation and take another picture; see your instruction manual or the onscreen help for suggestions.

3. Use your camera's playback control to compare the results. If you chose the correct scene mode, the picture you shot using that mode should be a better photo than the one shot in Auto mode.

SUNRISE, SUNSET

Whether you're on vacation in a tropical paradise or just enjoying the day on your back porch, you might see a spectacular sky display at sunrise or sunset. Unfortunately, your digital camera might seem blind to the colors and give you a dull photo like the one in Figure 5.3.

Figure 5.3—*It's a sunset, believe it or not, but Auto mode washes out the colors.*

If your camera has a Sunset scene option, though, you can get a better photo (see Figure 5.4).

Figure 5.4—*Use Sunset scene mode to get the colors you see at sunset (or sunrise).*

NIGHT

The default Auto mode fires the flash when lights are low. This works well if you're shooting subjects no more than 10 feet or so from your camera. However, if you're trying to capture the true feeling of the night, you might not be happy with the results (see Figure 5.5).

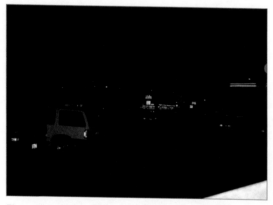

Figure 5.5—*If you shoot night photos in Auto mode, the flash fires, but anything beyond flash range is way too dark.*

To take pictures at night, you need a slow shutter speed (sometimes up to one second or longer) to allow a good exposure in dim light, and that's what modes such as Night or Night Scene provide (see Figure 5.6).

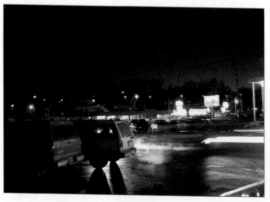

Figure 5.6—*Scene modes, such as Night or Night Scene, use slow shutter speeds (two seconds in this case) along with the flash to capture the mood of the night.*

If you want to use these scene modes, you'd better make sure you use a tripod or a very steady surface. If you look closely at the bright lights in Figure 5.6, you'll see a comma-shaped highlight caused by slight camera movement at the end of the photo (I braced the camera against the side of the car).

SNOW

Snow looks white to the eye, but because digital cameras assume that typical scenes are medium gray, snow photos in Auto mode turn the snow medium gray as well, as shown in Figure 5.7.

Figure 5.7—
Auto mode sees brilliant white scenes (such as snow) as medium gray.

Select Snow scene mode, though, and snow looks like snow, whether it's a sunny or overcast day (see Figure 5.8).

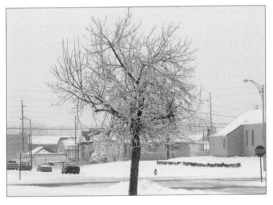

Figure 5.8—
Snow mode puts the white back in snow, and can also help reduce bluish color casts seen in some situations.

INTERIORS

In Auto mode, digital cameras typically fire the flash whenever you're inside because the light is much dimmer than outside. However, if you're trying to light up a stage, the flash built into the camera won't do much good, and you'll have pictures that are too dark with distorted colors as well (see Figure 5.9).

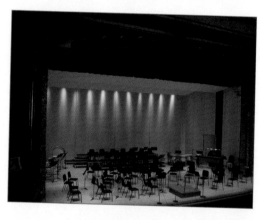

Figure 5.9—
Auto mode can't get good pictures of large building interiors.

Using a scene mode made for interiors helps the camera give you better exposure, and usually better color (see Figure 5.10).

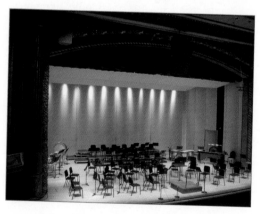

Figure 5.10—
Switch to a mode designed for inside use without flash to get better exposure and more accurate color.

Even if there's enough light to shoot without flash, Auto mode will usually have problems with incandescent/tungsten light used in many buildings (compare Figures 5.11 and 5.12).

Figure 5.11—
Auto mode's Auto color balance might not give you good color, even when there's enough light inside for your photos.

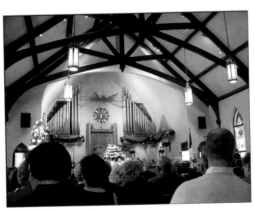

Figure 5.12—
Use scene modes made for inside shooting, and your pictures usually will have much more accurate color.

Depending on the camera, scenes designed for use inside without flash might be called Interior, Manner/Museum, or other terms. See your camera manual or Scene menu descriptions for details.

OTHER SCENE MODES

Here are just a few of the other scene modes you might find on typical digital cameras:

- **Sports mode**—Use this mode to handle fast-moving sports, action, or kids. Depending on the camera, this mode might switch to a different focusing system that continuously focuses on whatever's in the middle of the display (such as continuous or AI servo) and will usually select the fastest shutter speed possible.

- **Fireworks mode**—Use this mode for fireworks, neon signs, and other night situations. Make sure you use a tripod or a steady surface for shooting.

- **Portrait mode**—Use this mode for full-length to head-and-shoulder portraits. Depending on the camera, this mode might provide less sharp photos to reduce fine lines and wrinkles might set the camera to fire in burst mode, and usually will select the widest aperture possible to help blur out distracting backgrounds.

WHAT SCENES CAN'T DO

As the photos in this chapter show, choosing the right scene mode can make your photos a lot better. So, why bother to learn about stuff like shutter speeds, ISO settings, white balance, apertures, and focusing methods? Here are a few reasons it makes sense to learn how to use your camera's more advanced features:

- **Scene modes don't cover every shooting possibility**—No matter how many scene modes your camera includes (some have more than 20), you'll run into many shooting situations that don't really fit any available scene mode.

- **Scene modes don't always take advantage of your camera's best features**—As I used scene modes, I was surprised to see that ISO settings weren't increased as much as I would have done manually when shooting in dim light, and sometimes they were set to the lowest possible level. Using a low ISO forces the camera to use a slower shutter speed, which increases the risk of motion blur or camera shake.

- **Many cameras' scene modes don't permit manual overriding of some settings**—What if you want to change the white balance to do indoor portraits? Increase the ISO to handle dim lighting? You can't make these or other types of changes when you use scene modes on many cameras.

Simply put, scene modes can help you get better pictures, but they don't always know best. If your camera allows scene modes only as an alternative to Auto, use them. However, if your camera provides additional advanced controls, read on to learn how they can help you get better photos in a wider range of situations.

RECIPES FOR BETTER INDOOR AND NIGHT PICTURES

WHY YOU NEED THIS CHAPTER

It's easy to get great photos when the sun is shining. It's a lot tougher when you go indoors or stay outside after dark. This chapter helps you not be afraid of the dark by showing you how to get better pictures when the sun goes down and the artificial lights go on.

CHOOSING THE RIGHT ISO

To help your camera cope with low light, you need to select an ISO setting that's higher than the default Auto ISO (which covers a range of about ISO 80–250 on most cameras).

For most situations, increase your ISO (which enables your camera to take properly exposed photos in less light) to at least 400. By using ISO 400 or higher, you'll be able to get better flash photos at the far edge of flash range and you might be able to shut off the flash and shoot at hand-holdable shutter speeds with available light. Compare Figures 6.1 and 6.2.

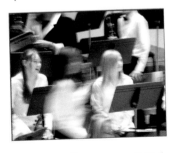

Figure 6.1—The camera selected ISO 160 for this shot, which caused camera shake and motion blur thanks to a 1/8-second shutter speed.

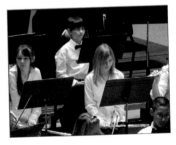

Figure 6.2—Same subject, same zoom setting, but by using a higher ISO (ISO 400), the shot is sharp and clear, thanks to a faster 1/40-second shutter speed.

How high can you go? Use the highest ISO setting that gives you satisfactory photos when printed (you really can't tell how sharp a high ISO photo is from viewing it on your camera's LCD display). For most recent point-and-shoot cameras, ISO 400–800 is usually the limit for acceptable picture quality when printed. For most DSLR cameras, you can usually go up to ISO 1600 and get acceptable quality, but you will still notice more grain and noise in your photos than you will see from images shot at a lower ISO setting. Because of this, use higher ISOs if there's no other way to get the photo—and you don't mind lower image quality as part of the deal.

→ *To learn more about choosing ISO settings, see the section "Using ISO Adjustments" on* **page 122**.

CHOOSING THE RIGHT WHITE BALANCE

When you shoot with flash, selecting the right white balance is easy. But if you want to turn off your flash, getting accurate color gets a bit trickier.

Here are the white balance rules of thumb for better color indoors:

- Using electronic flash on the Auto white balance setting works, but Daylight or Electronic flash white balance settings might produce a bit better color.

- If you're shooting under traditional incandescent bulbs, stage lighting, or spotlights, choose incandescent (Tungsten) white balance (compare Figures 6.3 and 6.4).

- If you're shooting under CFL lamps or fluorescent tubes, the right white balance choice isn't as easy as it sounds. Try the Fluorescent white balance setting if Auto does not produce accurate results. However, if your camera has more than one fluorescent white balance setting, try shots with each setting until you find the one that gives you the most accurate color.

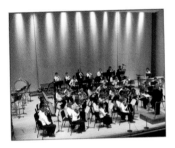

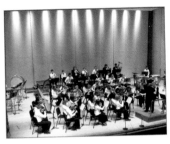

Figure 6.3—*Auto white balance makes stage lighting look too yellow.*

Figure 6.4—*However, switch to incandescent (tungsten) white balance and colors look more natural.*

- If you are using so-called "cool white" CFL bulbs and your photos are too blue, regardless of the fluorescent white balance setting you use, try Cloudy or Open Shade white balance.

TIP Different parts of your home or a public building can have different types of light. Remember to change your white balance setting as you shoot in different rooms, or when you switch between flash and available light. It's also common to have a mixture of light sources in the same space (fluorescent tubes overhead with daylight coming through large windows, for example). In those circumstances, try several different white balance settings to see which produces the most pleasing colors for the main subject in your composition. You can also create a custom white balance setting for that location.

→ *To learn more about choosing white balance settings, see "Why Use White Balance Settings?" in **Chapter 11**, "Improving Color."*

USING ELECTRONIC FLASH

Electronic flash is the easy way to take pictures inside or at night, but unless you pay attention to what you're doing, you won't get the kinds of pictures you'd like.

TOO-DARK FLASH PHOTOS

If your pictures are too dark, watch out for the following mistakes.

Shooting at a Distance too Far from Your Subject

Typical digital cameras (both point-and-shoot and DSLR models) have a flash range of about 10–15 feet. The onboard flash isn't very powerful, and the variable-aperture zoom lenses used by most cameras allow less light as you zoom beyond 1x. If you're getting results like Figure 6.5, walk closer to your subject and try again (see Figure 6.6).

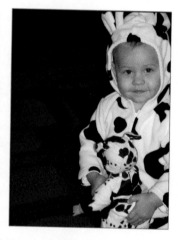

Figure 6.5—*It's a long shot—too far for the onboard flash to get a good photo.*

Figure 6.6—*Just walking closer provides enough extra light to get the photo you wanted.*

Using Auto ISO or an ISO Below 400

Auto ISO is the default ISO setting in Auto mode as well as other modes. The problem is that Auto ISO doesn't select high enough ISO settings for indoor or flash use (ISO 80–200 is typical). The electronic flash units built in to digital cameras often don't have enough light output to take well-exposed photos if you use ISO settings below 400, especially when you zoom in (compare Figures 6.7 and 6.8).

Figure 6.7—*The camera selected ISO 80 for a flash photo of a subject about 10 feet away—a recipe for a dark photo.*

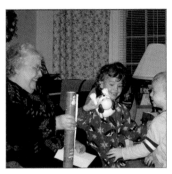

Figure 6.8—*Using ISO 400 enables a better flash shot from even farther away.*

If your camera doesn't let you choose a specific ISO, use the Hi ISO option (if available) for shooting indoors, at night, or with flash. This can also help you get better flash photos from farther away.

TOO-LIGHT FLASH PHOTOS

If your flash photos are too light, check the following.

Focus on the Background, Not the Subject

Your camera sets the flash exposure by focusing on your subject and setting the exposure based on the distance, camera ISO setting, and aperture. If you focus on the background, your main subject will be overexposed (too light) and out of focus, too (see Figure 6.9).

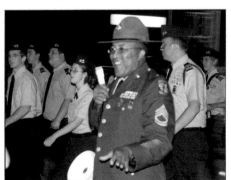

Figure 6.9—*The sergeant (center) is too light because the focus is on the marchers (background).*

To focus on moving objects, switch from single-shot to some type of continuous focus.

→ *To learn more about focusing methods, see **Chapter 14**, "Controlling What's in Focus."*

Subject at Angle to the Camera or at Different Distances From Camera

Professionals use multiple flash units and bounce panels to provide proper lighting for subjects at different distances from the camera. If you're using a single onboard or add-on flash, your subjects need to be at the same distance, or some will be lighter or darker than others (compare Figures 6.10 and 6.11).

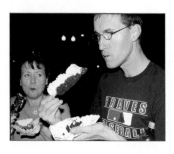

Figure 6.10—*When part of the group is much closer to the camera (right), you can't get the whole group properly exposed.*

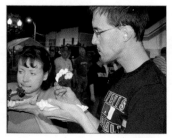

Figure 6.11—*Change the shooting angle so the members of the group are at about the same distance from the camera, and you get a better flash photo.*

OFF-COLOR FLASH PHOTOS

Off-color flash photos can be caused by a couple of problems.

Wrong White Balance Setting

If you change between flash and available light when shooting, be sure to reset the white balance appropriately. Figure 6.12 shows how using incandescent (tungsten) white balance with electronic flash (which uses a daylight, auto, or electronic flash white balance) produces an excessively blue photo compared to Figure 6.13.

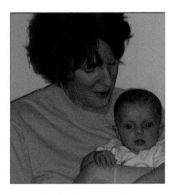

Figure 6.12—*Oops! Use incandescent (tungsten) white balance with electronic flash, and you have a blue photo—instantly.*

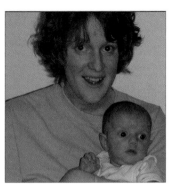

Figure 6.13—*Use Auto, Daylight, or Electronic Flash white balance for flash photos, and you get the colors you expect.*

Mixed Lighting

If you use flash in situations where background lighting is fairly bright (or you're using a slow shutter speed plus flash), you might find that the subject's color is OK but the background is not. This can happen anytime (with or without flash) when the light on the subject and on the background are different types (with different recommended white balance settings), as shown in Figure 6.11. There's not much you can do about it, unless you decide to shoot without flash.

AVAILABLE LIGHT AT HOME

Using available light at home helps you capture the mood of special moments like these.

BIRTHDAY CANDLES

Here's how to capture the warmth of birthday candles (see Figure 6.14):

White balance: Incandescent (tungsten)

ISO: 400, 800, or higher

Suggested modes: Shutter Priority (S, Tv)

Shutter speed: 1/30 second or slower

Aperture: f/1.8 to f/5.6

Scene mode: Fireplace, Candle Light, or similar

Zoom: 1x–3x

Notes: Use a tripod, monopod, or image stabilization (IS); use Hi ISO on cameras that don't provide specific ISO settings.

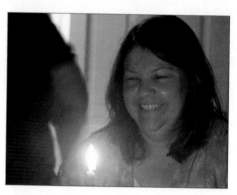

Figure 6.14—
Capturing the glow of birthday candles (ISO 1600, f/3.2, 1/10 second).

GROUP ACTIVITIES WITHOUT FLASH

Shooting a group without flash (see Figure 6.15)? Here are tips to get better photos:

White balance: As needed (incandescent or fluorescent if window light is not a factor; daylight or auto if window light is used on a sunny day; cloudy if window light is used on a cloudy day)

ISO: 400, 800, or Hi ISO

Suggested modes: Shutter Priority (S, Tv)

Shutter speed: 1/20 second or faster (preferred)

Aperture: Automatically set by camera

Scene mode: Indoor settings such as Manner/Museum

Zoom: 1x–3x

Notes: Use image stabilization (IS/VR) if available.

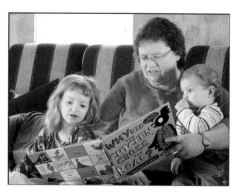

Figure 6.15—*No flash (1/60 second, ISO 400, f/5.0) means you won't distract your subjects.*

GROUP ACTIVITIES WITH FLASH

The more people (especially children) are in a flash picture, the harder it is to get good expressions. Use the following easy settings so you can concentrate on the subjects (see Figure 6.16):

White balance: Auto, Daylight, or Electronic Flash

ISO: 400 or Auto

Suggested modes: Auto or Program

Shutter speed: Automatically set by camera

Aperture: Automatically set by camera

Scene mode: Auto

Zoom: 1x–3x

Notes: Make sure the group is the same distance from the camera for best lighting, or use bounce flash. Hold your camera away from you or provide children with something to do so they don't mug for the camera as much.

Figure 6.16—
Keeping children occupied helps prevent posing for the camera.

PLAYTIME

Getting down where children play makes for better photos, as in Figure 6.17. Use these guidelines for better photos:

White balance: As needed

ISO: 400, 800, or Hi ISO

Suggested modes: Shutter Priority (S, Tv)

Shutter speed: 1/30 second or faster (preferred)

Aperture: Set automatically by camera

Scene mode: Indoor settings such as Manner/Museum; use Hi ISO

Zoom: 1x–4x

Notes: For children playing on the floor, shoot at a low angle. Hold your camera away from you so they don't mug for the camera as much. Use image stabilization (IS/VR) to help prevent camera shake.

WINDOW LIGHT AT HOME

To make shooting indoors easier in the daytime, open the window blinds or curtains and let the light in. You don't need your flash, white balance issues are minimized (Auto works well), and you can typically use faster shutter speeds than with lamps or ceiling lights. For better daytime shots, follow these guidelines:

Figure 6.17—*1/40 second, f/2.2, ISO 800.*

Electronic Flash: Use only as needed for fill flash.

White balance: Auto, Daylight, or Cloudy as needed for best color

ISO: 400, 800, or Hi ISO

Suggested modes: Shutter Priority (S, Tv)

Shutter speed: 1/30 second or faster (preferred); use image stabilization (IS)

Aperture: Set automatically by camera

Scene mode: Auto or Sports

Zoom: 1x–4x

Notes: Perform test shots with different white balance settings to determine the best white balance.

When you have plenty of daylight coming in, it's easy to get photos of children of all ages at play (see Figure 6.18). Indirect light (see Figure 6.19) is very flattering for all ages.

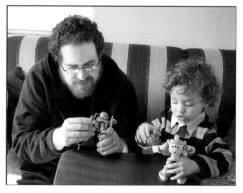

Figure 6.18— *There's plenty of daylight for this photo of dad and son at play (f/4.0, 1/40 second, ISO 800).*

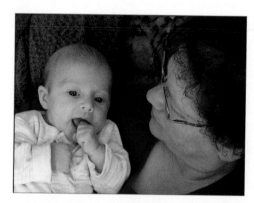

Figure 6.19—
*Indirect window
light helps grand-
mother and grand-
daughter look
their best.*

DEALING WITH "SPOTLIGHT" EFFECT FROM DIRECT SUN, DARK BACKGROUND

Use -0.7 EV to -1.0 EV to avoid overexposing the subject (see Figure 6.20).

Figure 6.20—*Using -0.7
EV (which cuts recom-
mended exposure nearly
in half) prevents the
camera from overexpos-
ing the main subject.*

DEALING WITH BACKLIT SUBJECTS

Use +0.5 to +1 EV to avoid underexposing the subject, or use fill flash (see Figure 6.21).

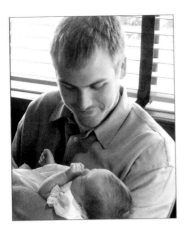

Figure 6.21—*Using +0.7 EV compensates for the bright background of an open window behind the subject.*

INDOOR SPORTING EVENTS

The following are general guidelines (see Figures 6.22 through 6.25):

Electronic Flash: Use only add-on flash if available because built-in flash doesn't have enough range.

White balance: Fluorescent, incandescent, or auto as needed for best color without flash; use auto, daylight, or electronic flash with flash.

ISO: 400, 800, 1600, or Hi ISO

Suggested modes: Shutter Priority (S, Tv) for shooting without flash; with flash, use Program

Shutter speed: 1/125 second or faster (preferred); use image stabilization (IS)

Aperture: Set automatically by camera

Scene mode: Sports (without flash)

Zoom: 1x–4x

Notes: Perform test shots with different white balance settings to determine the best white balance. Use Servo or continuous focus. Use flash only if it has a range of 25 feet or greater (typically, add-on flash).

To get better photos, try the following techniques.

PREFOCUS ON WHERE YOUR SUBJECT WILL BE INSTEAD OF TRYING TO TRACK THEM

If you're shooting basketball, volleyball, or gymnastics, you might have a hard time getting your camera to focus quickly enough to make the shot. If possible, prefocus on the floor, parallel bars, or other objects using focus/exposure lock and wait for the action to come to you. In Figure 6.22, I focused on the basket and waited for a layup.

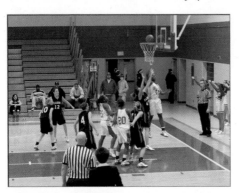

Figure 6.22—*Using focus/exposure lock and waiting for a play helps you get better photos if your camera can't focus quickly (1/125 second, f/4.0, ISO 1600).*

USE PANNING IF YOU CAN'T USE A REALLY FAST SHUTTER SPEED

If you can't shoot at shutter speeds of 1/250 second or faster, panning your camera to follow the action might be the best way to get action photos (see Figure 6.23).

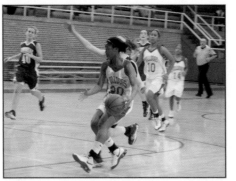

Figure 6.23—*Panning the camera to follow the player with the basketball makes a relatively slow shutter speed (1/200 second) work for this photo.*

IF YOU HAVE AN ADD-ON FLASH, PUT IT TO WORK

Add-on flash units have much longer ranges than built-in flash, and you can use them to get good photos in dimly lit

gymnasiums (see Figure 6.24); however, watch out for slow shutter speeds.

Be sure to use fresh batteries; otherwise, your add-on flash might not fire consistently and you'll get motion-blurred fuzzy photos whenever the flash fails to fire.

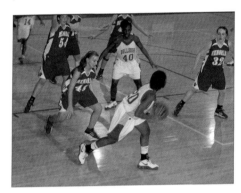

Figure 6.24—*The flash stops the action, but if you use a shutter speed under 1/200 second (here we used 1/60 second), you might have some secondary blur.*

CHOOSE THE RIGHT AUTOFOCUS METHOD TO TRACK A MOVING SUBJECT

Most digital cameras are set to autofocus for a single shot. When you press the button, the focus and exposure is locked, and then you take the picture. The problem is that the subject might have moved closer or farther away from you and is out of focus between the time you lock focus and take the picture (see Figure 6.25). For better results, use an autofocus method that continuously focuses, such as Servo or continuous focus (refer to Figure 6.23) but remember to keep the subject centered.

Figure 6.25—*Single-shot focus often focuses on the back-ground.*

→ *To learn more about focusing methods, see* **Chapter 14,**
 "Controlling What's in Focus "

NIGHT SPORTING EVENTS

The following are some general guidelines for nighttime sport-
ing events (see Figures 6.26 and 27):

Electronic Flash: No

White balance: Incandescent, fluorescent, or auto as needed
for best color

ISO: 400, 800, 1600, or Hi ISO

Suggested modes: Shutter Priority (S, Tv)

Shutter speed: 1/125 second or faster (preferred); use image
stabilization (IS/VR)

Aperture: Set automatically by camera

Scene mode: Sports with Hi ISO enabled

Zoom: 3x–8x

Notes: Perform test shots with different white balance settings
to determine the best white balance for your present location.
Use Servo or continuous focus.

To get better photos, try the following techniques.

LOOK FOR SHOTS THAT CAPTURE THE MOOD IF YOU CAN'T CAPTURE THE ACTION

If your attempts to capture action are hopelessly blurred
because you can't use a fast enough shutter speed (see
Chapter 12, "Stopping Action," for examples), look for photo
ops that don't demand as much of your camera, such as cheer-
leaders or players preparing for the next play (Figure 6.26).

PREFOCUS ON THE PLAYMAKER

If you're shooting football, keep your eye (and focus) on the
quarterback. Whether he makes a handoff or a pass (Figure
6.27), he'll be the center of the action on most plays. If you're
shooting soccer, prefocus on your favorite players' most-often
used field locations. You can also use Servo or continuous focus.

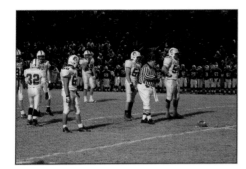

Figure 6.26—*1/50 second is all you need to shoot the pause before the next defensive stand.*

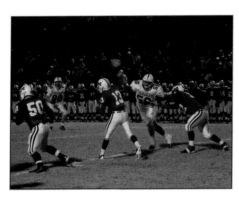

Figure 6.27—*Want football action? The quarterback's the place to look (and shoot).*

USE MANUAL FOCUS IF YOUR CAMERA SUPPORTS IT

To prefocus most effectively with a DSLR, switch the camera or lens to manual focus mode (some point-and-shoot cameras also support manual focus). If you use manual focus, remember that you're in charge of focusing, and be sure to practice before the "big game." See Chapter 14 for details.

CHURCHES AND MUSEUMS

The following are general guidelines for shooting photos in churches and museums (see Figures 6.28 and 29):

Electronic Flash: No

White balance: As needed for best color (typically incandescent or fluorescent)

ISC: 400, 800, or Hi ISO

Suggested modes: Shutter Priority (S, Tv)

Shutter speed: 1/30 second or faster (preferred)

Aperture: Automatically set by camera

Scene mode: Indoor settings such as Manner/Museum and Party/Indoor that do not use flash.

Zoom: 1x–4x

Notes: Use image stabilization (IS/VR) if available, or use a tripod, monopod, or steady surface.

Figure 6.28—*Auto mode (left) versus Manner/Museum scene mode (right) on a Kodak point-and-shoot camera. Manner/Museum adjusts the white balance, turns off the flash, and turns off camera beeps for discreet photos.*

Figure 6.29—*Exposing for the interior washes out detail in stained glass windows; use -1 to -2 EV (seen here) to capture the full beauty of the windows.*

CONCERTS AND PERFORMANCES

The following are general guidelines for shooting concerts or other performances (see Figures 6.30 and 6.31):

Electronic Flash: No

White balance: As needed for best color (typically incandescent or fluorescent)

ISO: 400, 800, or Hi ISO

Suggested modes: Aperture Priority (A, Av)

Shutter speed: Automatically set by the camera (recommended: 1/30 second or faster)

Aperture: f/2.8 to f/4.0

Scene mode: Indoor settings such as Manner/Museum and Party/Indoor that do not use flash.

Zoom: 3x–10x

Notes: Use image stabilization (IS/VR) if available, or use a tripod, monopod, or steady surface to prevent camera shake.

In a school gymnasium setting (Figure 6.30), sit at a location that enables you to get a photo without a lot of foreground clutter, and focus on your performer's face.

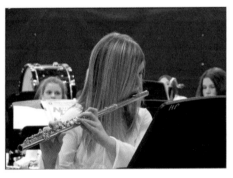

Figure 6.30—*A fairly fast (f/3.6) lens opening enables a 1/25-second shutter speed and a nicely blurred background (ISO 400) at 4x zoom.*

In a professional auditorium (Figure 6.31), you might need to use -1 EV to avoid overexposing featured performers in the spotlight. The front of the balcony provides an unobstructed view of performers in any part of the orchestra.

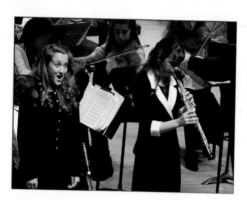

Figure 6.31—*1 EV enables the featured performers to stand out from the more dimly lit ensemble behind them (ISO 400, 1/40 second, f/6.3, 9x zoom).*

FIREWORKS

Here's how to get better fireworks photos (see Figure 6.32):

Electronic Flash: No

White balance: Auto or Daylight (preferred)

ISO: 64–200 or Auto

Suggested modes: Manual

Shutter speed: 1–3 seconds

Aperture: f/4.0 to f/8.0

Scene mode: Fireworks

Zoom: As needed

Notes: Use a tripod or steady surface. Check exposure after your first couple of shots and adjust as needed. Use manual focus or infinity focus.

If you use too fast shutter speed, fireworks don't have a chance to fully bloom. Figure 6.32 shows that a slow shutter speed and an unobstructed view pays off with better photos.

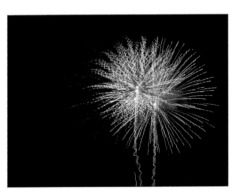

Figure 6.32—*3.2 second, ISO 100, f/6.3 produces great results.*

PORTRAITS

A portrait can be posed (see Figure 6.33) or shot on the spur of the moment (see Figure 6.34), but a good portrait has these elements: It captures the personality of the subjects and focuses your attention on them. Here are some general guidelines to help you get better portraits:

Electronic Flash: No (preferred) or as needed

White balance: As needed for best color (incandescent or fluorescent without flash; auto or daylight with flash).

ISO: 400, 800, or Hi ISO (no flash); ISO 100–400 (with flash)

Suggested modes: Aperture Priority (A, Av)

Shutter speed: Automatically set by camera (recommended: 1/30 second or faster)

Aperture: f/2.0 to f/5.6

Scene mode: Indoor portrait or portrait (turn off flash if not desired)

Zoom: 2x–5x

Notes: Use image stabilization (IS/VR) if available, or use a tripod, monopod, or steady surface.

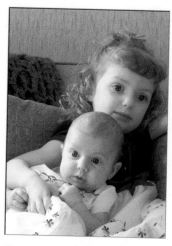

Figure 6.33—*Sisters; my son and daughter-in-law used this portrait for their Christmas card (3x, f/5.1, 1/25 second, ISO 400).*

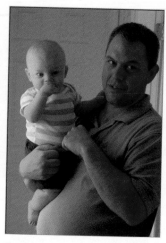

Figure 6.34—*Father and son (3x, f/4.2, 1/12 second, ISO 400).*

CAMPFIRES

Want to capture the relaxed feel of a campfire at dusk (see Figure 6.35)? Here's how:

Electronic Flash: No

White balance: Incandescent

ISO: 800 or higher or Hi ISO

Suggested modes: Manual

Shutter speed: 1/10 to 1 second

Aperture: f/2.0 to f/5.6

Scene mode: Candle Light or Firelight

Zoom: As needed

Notes: Use a tripod, monopod, or steady surface.

Figure 6.35—*A good combination of sunset, firelight, and shadows, along with a cooperative subject and steady camera, make for a winning shot (1/6 second, ISO 1600, f/3.5, 1x zoom).*

PETS

Love your pets? Love your pet photos with these guidelines:

Electronic Flash: Not recommended (see Figure 6.36 to learn why)

White balance: As needed for best color (typically incandescent or fluorescent without flash; Auto, Daylight, or Electronic Flash with electronic flash)

ISO: 400, 800, or Hi ISO

Suggested modes: Shutter Priority (S, Tv)

Shutter speed: 1/30 second or faster (recommended)

Aperture: f/1.8 to f/5.6

Scene mode: Pets and Kids, Sports, other modes made for action

Zoom: As desired

Notes: Use image stabilization (IS/VR) if available, or use a tripod, monopod, or steady surface. Use Servo or continuous focus to keep your pet in focus.

As Figure 6.36 demonstrates, pet eyes and electronic flash are not a good combination. If you must use flash, use Auto or Daylight white balance and keep your ISO at 400 or less, and make sure your pet is not looking into the camera. If you have an add-on flash with a swivel head, aim the flash head up and use a bounce card.

Figure 6.37, contributed by the family's pet portrait specialist (my son Jeremy Soper), uses backlighting and selective focus to great advantage.

Figure 6.36—*Good dog, good! Bad flash, bad (gives good dog evil green eyes)!*

Figure 6.37—*Flower at rest (ISO 800, 1/30 second, f/1.8, manual exposure).*

MIXED LIGHTING

Dealing with mixed lighting sources, whether it's an open window along with incandescent lighting or other combinations of light with different characteristics, can drive you crazy with off-color overtones. Sometimes, the best fix is to set your white balance for the background light and replace the original lighting with fill flash (see Figure 6.38), while in other circumstances you might prefer to get rid of the clashing light source altogether by closing the door, closing the drapes, or turning off the lights.

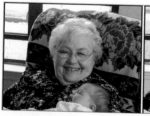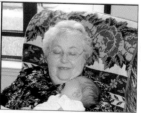

Figure 6.38—*A mix of incandescent light and window light (left) with incandescent white balance creates blue highlights, but Auto white balance and a dose of electronic fill flash provides better color (right).*

RECIPES FOR BETTER DAYTIME PICTURES

WHY YOU NEED THIS CHAPTER

If all you want is a picture when the sun is shining, just push the shutter button of your digital camera. But if you want to create daytime photos that people will enjoy viewing, pictures that will bring back special memories of vacations or other special days, you'll want to learn how to use your camera's special features. That's what this chapter is all about.

CHOOSING THE RIGHT APERTURE

The choice of aperture has a big impact on your outdoor photos because it affects the depth of field (how much of the photo is in sharp focus from front to back). If you use Auto or Program mode, you have no choice in aperture settings; with these settings, the brighter the scene, the smaller the aperture and faster the shutter speed. If you're shooting portraits or landscapes, though, you'll want to select your own aperture.

PORTRAITS

For portraits (see Figures 7.1 and 7.2), you want to focus on the subject and blur out the background. To do this, select a wide aperture (f/1.8 to f/5.6) because these apertures have shallower depth of field than narrower apertures. If you cannot select a wide aperture in Aperture Priority mode without overexposing your photo, select a low ISO (200 or less).

Figure 7.1—What's the subject? 1x zoom and f/7.5 aperture combine to make the background rival the subject for sharpness.

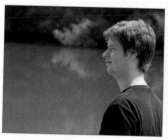

Figure 7.2—There's no question about the subject this time! 5x zoom and f/5.6 aperture help blur out the background (ISO 200).

LANDSCAPES

For landscapes (see Figure 7.3), you usually want the entire photo to be in focus. If the landscape has objects at different distances from the camera, you might need to use narrow apertures (f/8.0 and smaller) to achieve the desired depth of field. When you use narrow apertures, you must watch out for shutter speeds that are too slow to hand-hold successfully.

Figure 7.3—A 3x (55mm) lens and narrow f/14 aperture capture both the near bank tree and the far side of the New River Gorge bridge in sharp focus.

CHOOSING THE RIGHT ISO

If you're not worrying about how much of the picture's in focus, you can use Auto ISO or ISO 200 on a sunny day and you'll usually get sharp photos. However, there are situations, even outdoors, where changing to a higher or lower ISO makes sense.

WHEN TO USE A HIGHER (FASTER) ISO

With a higher (faster) ISO, you can use narrower apertures or faster shutter speeds and still have enough light to shoot by, even with very long (10x or longer) zoom lenses.

If your camera cannot provide a hand-holdable shutter speed when you use Aperture Priority and select the aperture you want, you have a couple of choices: Increase the ISO to 400, or use a tripod.

If you are shooting with long lenses (8x or longer; 200mm or longer on most DSLRs; 100mm or longer on Olympus DSLRs), the issue of hand-holdable shutter speeds becomes even more critical: High zoom ratios not only bring distant subjects closer but also magnify every hand tremor. If you find that Auto ISO doesn't let you use a fast enough shutter speed to hand-hold your long zoom shots, use a higher ISO (400 or greater), enable image stabilization (IS/VR), or use a monopod or tripod.

Using ISO 400 or higher on cloudy days, around dawn, or around dusk also enables you to avoid camera shake, no matter what shooting mode you're using.

WHEN TO USE A LOWER (SLOWER) ISO

If you want to use selective focus techniques outdoors to emphasize your subject, or if you want to use panning to capture a feeling of speed, you might need to use lower ISOs on your camera than what Auto ISO might select when you shoot with 1x–4x zooms. By using a low ISO (ISO 64–200), you can use the limited depth of field created by wide apertures to control what's in focus, or use slower shutter speeds for creative effects (compare Figures 7.4 and 7.5).

Figure 7.4—At ISO 1600, the camera uses an action-stopping 1/320-second shutter speed.

Figure 7.5—At ISO 100, the camera uses 1/25-second shutter speed so you get the sensation of speed from a blurred background).

→ To learn more about choosing ISO settings, see the section "Using ISO Adjustments" on **page 122**.

→ To learn more about IS/VR technology, see the section "Using Anti-Shake Technologies" on **page 196**.

CHOOSING THE RIGHT WHITE BALANCE

Here are the rules of thumb for better color outdoors:

■ On sunny days, use Auto white balance or, for more vivid colors, use Daylight white balance (see Figure 7.6).

■ On overcast days, if you notice the colors are too blue, use Cloudy or Open Shade white balance (see Figure 7.7).

■ If your camera has both Cloudy and Open Shade white balance settings, try Cloudy first. Use Open Shade if pictures are too blue when using Cloudy.

1. Deeper Blue

2. More Intense Green

3. More Saturated Gray

4. More Vivid Gold

Figure 7.6—*Auto white balance (left) produces acceptable colors, but Daylight white balance (right) produces more vivid colors on a sunny day.*

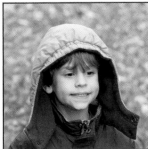
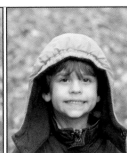

Figure 7.7—*A comparison of daylight (left) and open shade (right) white balance settings.*

You can also use Custom white balance outdoors as well as indoors.

CAUTION If you use Custom white balance, don't forget to check your results frequently. White balance shifts during the day from warm to cool to warm again as you go from sunrise to high noon to sunset. If you don't change Custom white balance when the light changes, you will have off-color photos that will need to be corrected with photo editing software.

→ *To learn more about choosing the best white balance settings, see **Chapter 11**, "Improving Color."*

CHOOSING THE RIGHT SHUTTER SPEED

How important is shutter speed when you're shooting outdoors? It depends on the subject. When you're shooting action, you'll probably want to use shutter speeds of 1/500 second and faster. However, if you're trying to capture the look of moving water, shutter speeds of 1/250 second and slower are better.

LANDSCAPES

Here are some general guidelines for better landscape photos:

White balance: Daylight (preferred) or Auto

ISO: Up to 400

Suggested modes: Aperture Priority (A, Av)

Shutter speed: Set automatically by camera

Aperture: f/1.8 to f/5.6 (selective focus on details); f/5.6 or narrower (overall shot in focus)

Scene mode: Auto, Beach, Snow as needed

Zoom: As needed

Notes: Shoot before 11 a.m. or after 2 p.m. for the best light. Use a tripod or image stabilization (IS) to prevent camera shake.

DIRECTIONAL LIGHTING

The light is lower in the morning and afternoon, and it can provide some outstanding "spotlight" effects, as shown in Figure 7.8.

To get the full benefit of directional lighting, though, make sure you're shooting at an angle where you can see both highlights and shadows. Compare Figures 7.9 and 7.10.

Figure 7.8—*The low sun angle brings out the details of the dog and the dog walkers (f/16, 1/60 second, ISO 200, 2x zoom).*

Figure 7.9—*The sun is to the left of the towboat, so the entire side of the boat is in shadow.*

Figure 7.10—*Wait just a few seconds, though, and the same subject provides a dramatic mix of light and shadows.*

BUILDINGS AND ARCHITECTURE

Here are some general guidelines for better building and architectural photos:

White balance: Daylight (preferred) or Auto

ISO: Up to 400

Suggested modes: Aperture Priority (A, Av)

Shutter speed: Set automatically by camera

Aperture: f/1.8 to f/5.6 (selective focus on details); f/5.6 or narrower (overall shot in focus)

Scene mode: Auto, Beach, Snow as needed

Zoom: As needed

Notes: Shoot before 11 a.m. or after 2 p.m. for the best light. Use a tripod or image stabilization (IS) to prevent camera shake. Use EV adjustment as needed to bring out details.

Figure 7.11 is one of a series I did for a local newspaper on an historic neighborhood. I used +0.3 EV to add a bit more exposure to bring out shadow detail. The morning light brought out building detail and made the flag the center of attention.

Figure 7.11—*Deep depth of field, thanks to f/14 aperture and a wide-angle lens (22mm, 1.1x), helps capture the essence of a neighborhood in a single shot.*

WHY DETAILS MATTER

Overall shots, such as Figure 7.12, help establish the scene, but to capture the real essence of an interesting building or structure, be sure to look for details (see Figure 7.13). I used -0.7 EV in both photos to darken the sky and make the shadows deeper.

1. The Detail Shown in Figure 7.13

Figure 7.12—
An overall shot of the Lincoln Memorial Bridge in Vincennes, Indiana.

Figure 7.13—*Detail of the Lincoln Memorial Bridge. Note how the afternoon light brings out the bas-relief.*

SHOOTING FROM THE INSIDE TO CAPTURE SPECIAL DETAILS

The early 1900s house shown in Figure 7.14 was decorated for the 4th of July. To capture the unique flavor of the home's rare beveled-pane windows, I took a picture of the bunting through the window.

Figure 7.14—
Beveled-pane windows turn any view into a unique experience.

CHILDREN

It's easier to get pictures of children outside, but that doesn't mean it's easy to get good pictures. Follow these guidelines to help you get better photos:

White balance: Daylight (preferred) or Auto when it's sunny; switch to Cloudy or Open Shade when it's overcast

ISO: 200–400 (sunny); 400–800 (overcast)

Suggested modes: Shutter Priority (S, Tv)

Shutter speed: 1/125 to 1/500 or faster

Aperture: Set automatically by camera

Scene mode: Sports, Kids and Pets, or similar action-oriented modes. Use Hi ISO if pictures are too dark or are blurred by camera shake or subject motion.

Zoom: As needed

Notes: Shoot before 10 a.m. or after 2 p.m. for the best light. Use image stabilization (IS) to prevent camera shake. Use Servo or continuous focus.

GET CLOSER...AND USE THE RIGHT FRAMING

Wide-angle shots can cover up the subject with clutter (see Figure 7.15). Use your zoom lens to get in closer for better photos (see Figure 7.16). Figure 7.16 also demonstrates that holding the camera sideways (vertical) works better for some shots.

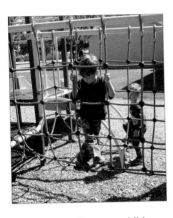

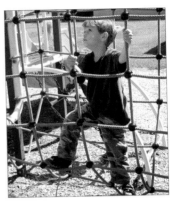

Figure 7.15—*There are children inside the rope ladder. Can you see them? (1.1x zoom)*

Figure 7.16—*Flip the camera to vertical, zoom in (4x), and now the main subject is easy to see.*

...but don't get too close, as shown in Figures 7.17 and 7.18.

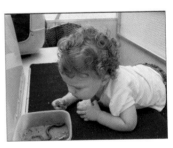

Figure 7.17—*Too tight a shot makes the viewer feel uncomfortable.*

Figure 7.18—*Back up a bit and it's easier to see what's going on.*

HOW TO UNCLUTTER THE BACKGROUND

Shooting against the sky helps make children at play stand out (Figure 7.19), while using a wide aperture to blur out the background helps capture quieter moments (Figure 7.20).

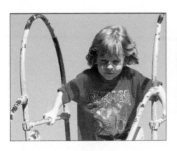

Figure 7.19—*The blue sky makes for a nice contrast with the red T-shirt (12x zoom).*

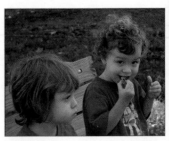

Figure 7.20—*This close encounter of the salted-in-the-shell peanut kind uses a 4x zoom and wide f/3.6 aperture to blur out the background.*

SHOOTING AT DAWN AND DUSK

Shooting around sunrise or sunset means dealing with rapid changes in lighting, concerns about white balance, and high ISO and low shutter speeds. However, you can get some great photos if you're careful by using these guidelines:

White balance: Daylight (captures the redness in the sky at sunrise and sunset); Cloudy or Open Shade (before sunrise or after sunset; use when skin tones become blue)

ISO: 400–800 before and at sunrise; during and after sunset

Suggested modes: Shutter Priority (S, Tv) or Aperture Priority (A, Av)

Shutter speed: If hand-held, 1/30 second or faster (Shutter Priority); set automatically by camera (Aperture Priority)

Aperture: f/1.8 to f/5.6 (Aperture Priority); set automatically by camera (Shutter Priority)

Scene mode: Sunset while sky is red; Night scene after sunset or before sunrise

Zoom: As needed

Notes: Use image stabilization (IS), a tripod, or a steady surface to prevent camera shake. Use a short (2-second) self-timer if you are not shooting moving subjects.

SUNRISE, SUNSET

No matter how simple or how complex your digital camera is, it's easy to control how intense a sunrise or sunset is: It all depends on where you lock your focus and exposure (see Figure 7.21).

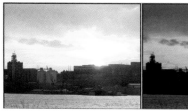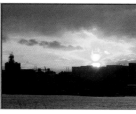

Figure 7.21—*Locking exposure on the water, and then raising the camera to aim at the sunset, brings out building detail at the sacrifice of the sunset's intensity (left), while locking exposure on the sky silhouettes the buildings but captures the full majesty of the sunset (right).*

→　*To learn more about exposure lock, see the section "Using Exposure Lock" on **page 116**.*

 NOTE　Be sure to use Sunset scene mode on a scene-driven camera to capture the full color of the sunset.

BUILDINGS AT DUSK

The combination of a fading sunset and brightly lit buildings can provide striking photographs (see Figure 7.22). Be sure to use a tripod or place the camera on a steady surface to avoid camera shake because exposures will often be in the 1/8-second or slower range.

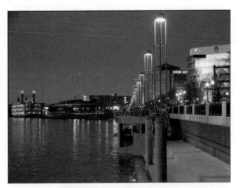

Figure 7.22—*Neon, streetlights, and sunset combine to create a magical view (1/8 second, ISO 400, f/3.6 on a point-and-shoot camera).*

BETTER PEOPLE PHOTOS

People and other subjects look better when you avoid front and overhead lighting. For better photos of family and friends of any age, use these tips to supplement the exposure settings needed for the lighting conditions.

AVOID OVERHEAD LIGHTING

I recommend shooting before 10 a.m. and after 2 p.m. because the sun casts longer, more interesting shadows, and with people, it's easier to avoid shadows on the face (see Figure 7.23).

Figure 7.23—*High noon is a good time for lunch, not photos. Note the heavy shadows across the face.*

BACKLIGHT IS FLATTERING, BUT WATCH THE EXPOSURE

Shooting your subjects when they face away from the sun helps the face to relax and captures a halo effect around the hair (see Figure 7.24). In some cases (but not in this photo), you might need to increase exposure by +0.7 to +1.0 EV.

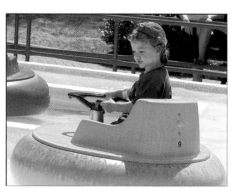

Figure 7.24—
Backlighting outlines the subject.

DISTRACTING BACKGROUND? BLUR IT AWAY

One of the reasons I prefer wide-aperture (f/2.8 and faster) lenses is because they make it easier to blur out the background. Compare Figures 7.25 and 7.26.

Figure 7.25—*At f/5.6 (2.75x/50mm), the background is distracting.*

Figure 7.26—*At f/2.8 (2.75x/50mm), the background is blurred out.*

On scene-driven cameras, use Portrait mode to help blur out the background.

ACTION AIR-LAND-WATER

Want to capture good action photos? It's harder than it looks. You could just bump up the ISO to 400 or 800, select the fastest shutter speed possible, or select Sports mode and shoot away. This approach will get you a lot of stop-action photos, but they might not convey the feeling of action. To help convey action, try the following techniques.

USING SMOKE

Smoke from historic rifles helps convey the feeling of action in your photos (see Figure 7.27). Water spray from speedboats is also effective (see Chapter 12, "Stopping Action," for details).

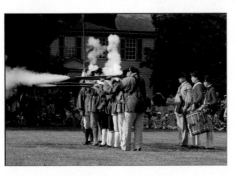

Figure 7.27—*0.7 EV keeps the foreground from being overexposed, and prefocusing on the squad makes it easier to shoot at the right time.*

USING PANNING

Panning helps streak the background for a feeling of speed when shooting fast cars, boats, or airplanes (see Figure 7.28).

 TIP Use burst mode to help capture split-second events.

→ *For more about burst mode and panning, see **Chapter 12**, "Stopping Action."*

Figure 7.28—*When panning a very high-speed subject, like this P-51 warbird, use shutter speeds of up to 1/400 second.*

VACATIONS

To make your vacation pictures stand out from the rest, look for unusual ways to view your subjects. Here's a small sampling.

A NEW TAKE ON DISNEY WORLD

The Walt Disney and Mickey Mouse statue is in front of the Disney World Cinderella castle (see Figure 7.29). For a new perspective, I walked next to the statue and saw that Disney was "blessing" his creation (see Figure 7.30).

Figure 7.30—*Change your angle, and see how the subject interacts with the background.*

Figure 7.29—*How to get a new perspective on an overdone subject.*

AT THE ZOO

Enclosures can be a big problem (Figure 7.31), but by shooting through or over the fence, or shooting where there is no fence (Figure 7.32), you can get some intriguing photos.

Figure 7.31—*The chain-link fence is quite visible, even with a wide aperture (f/4.0) so if possible, try to place your lens against the fence and shoot through a gap in the links.*

Figure 7.32—*A very limber wild horse.*

RECIPES FOR BETTER EVENT PICTURES

In this chapter, we'll be looking at ways to help you better capture the most significant events in life: weddings, baptisms, birthdays, family reunions, and holidays.

WEDDINGS

Unless you're in the wrong place at the wrong time, you probably won't be asked to be the official wedding photographer. However, don't put your camera away. The pictures you get of the wedding party, the wedding itself, and the reception will be a welcome addition to the photos the professionals take.

BEFORE THE WEDDING

Whether you're a member of the wedding party or just a guest, there are plenty of opportunities to get great photos before the ceremony starts.

Capturing the Scene

Whether the wedding will be in a church, outdoors, or at a special destination, get some photos of the location before the wedding starts (see Figures 8.1 through 8.3).

To shoot on a sunny or partly cloudy day, use ISO 200–400 and the appropriate white balance (sunny or cloudy). For architectural shots like these, use Aperture Priority and select a moderate (f/5.6 or narrower) aperture. Scene-based cameras can use Auto mode.

Figure 8.1—*Don't confine yourself to shots of the venue; look for photos of the nearby surroundings (New Harmony, Indiana).*

If the wedding will be in a tall building, avoid using a wide-angle lens (1x–2x) at close range for exterior photos because tilting the camera results in distortion, as shown in Figure 8.2.

Figure 8.2—*Wide-angle (1x, 18mm) shots make a tall building seem to lean back.*

Figure 8.3—*The distortion-correction filter in Adobe Photoshop and Adobe Photoshop Elements corrects the problem, but note that the edges of the photo have been lost in the process.*

Some image editors, such as Photoshop Elements 6 and later now include a distortion control feature that can straighten converging lines for even better results after the fact (refer to Figure 8.3).

Moving from Outdoors to Indoors

If you've been taking pictures outdoors and then move indoors, be sure to change camera settings such as ISO and white balance as needed; otherwise, your indoor shots might be very dark and off-color (compare Figures 8.4 and 8.5).

Figure 8.4—*1/60 second at ISO 400 produces a very dark photo in this restaurant.*

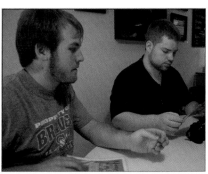

Figure 8.5—*Increasing the ISO to 1600 enables me to use the same shutter speed to avoid camera shake and still get a good available-light photo.*

Preparations for the Ceremony

You can make the most of wedding ceremony preparations by using 1x–4x zoom range. For indoor shots without flash (Figures 8.6 and 8.7), use ISO 400–1600 and the appropriate incandescent or fluorescent white balance settings to capture special moments. With scene-based settings, use Hi ISO and choose an indoor shooting mode that provides good white balance.

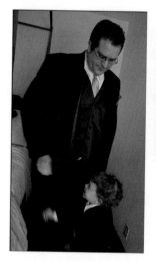

Figure 8.7—*The groom gets some last-minute advice. I included the mirror in my composition to help "open up" the small room.*

Figure 8.6—*Tall father, small son prepare for the wedding.*

SHOOTING THE CEREMONY

For the best pictures of the procession and the ceremony, get yourself an aisle seat. However, even then, watch out for obstructions (compare Figures 8.8 and 8.9).

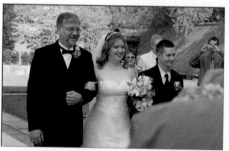

Figure 8.8—*Other guests can block your view of the procession, especially if you shoot too soon (3x zoom).*

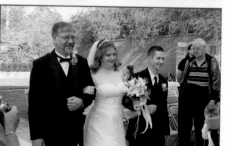

Figure 8.9—*Zoom back to about 2x, wait a moment, and if you're on the aisle, you can get an unobstructed shot.*

If you're shooting without flash, watch out for exposure problems that can be caused by the background being much brighter or darker than the subject (compare Figures 8.10 and 8.11).

Figure 8.10—*The dark suits worn by the wedding party fool the camera, overexposing the shot.*

Figure 8.11— *Reducing exposure a bit (-0.3 EV) fixes the problem.*

Be ready for both the events you expect (Figure 8.12) and the reaction you might not be expecting (Figure 8.13).

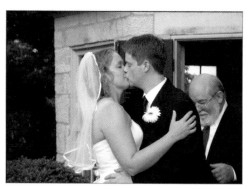

Figure 8.12—*The moment everyone waits for (the first kiss as husband and wife)...*

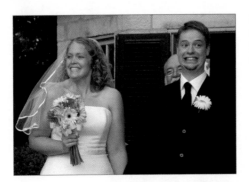

Figure 8.13—...and the reaction nobody expected (but loved anyway).

TIP Most weddings (unlike the examples here) take place indoors. Most built-in flash units can't recharge fast enough to capture sequences. If you must use flash and you have a camera with a hot shoe for flash, consider buying an add-on electronic flash. They can shoot much faster than built-in flash units, use interchangeable batteries, and provide you with more range.

SHOOTING THE RECEPTION

There are even more opportunities for photos at the reception. The professional photographer will handle events such as the cake cutting and the first dance, so why not shoot something different, such as unusual dance partners (Figure 8.14) or other special moments (Figure 8.15)?

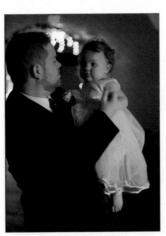

Figure 8.14—A very young lady's first dance with her uncle.

If the reception's at a public hall, getting a photo of the "Congrats" sign is a nice addition to the album. You can use Auto mode to shoot the sign in the daytime, but at night (see Figure 8.16), you'll probably need to use Manual exposure and try several different settings because Auto will overexpose the text.

Figure 8.15—*Don't let dance-floor lighting stop you from getting tender moments like these.*

Figure 8.16—*The congratulations sign.*

HOLIDAYS, SHOWERS, AND BIRTHDAYS

If you want to get better photos of the fun, don't stick yourself in a corner unless you like pictures of the backs of family and friends. Instead, position yourself so the action surrounds you. If you're getting flash shots like Figure 8.17 when you use 3x or 4x zoom, increase your camera's ISO to 400 and you'll do better (see Figure 8.18).

Figure 8.17—*Flash shots at 3x–4x can fail because the lens opening narrows and the camera may select a low ISO (ISO 80 in this example).*

Figure 8.18—*Increase your ISO setting to ISO 400, and the camera's built-in flash can do a better job at 3x and beyond.*

For photos of children, low-angle shots help capture a child's-eye view of the wonders of the occasion (see Figure 8.19).

Figure 8.19—*To see the world from a child's eyes, get down on her level.*

NEW BABY IN TOWN

There are plenty of milestones in the life of a new baby, but when they're new, it can sometimes be hard to get good photos (see Figure 8.20).

If you'd like a break from the usual "hugging the newborn" photos, try using a firm support, use a 3x or 4x zoom, and watch for some intriguing faces (see Figure 8.21).

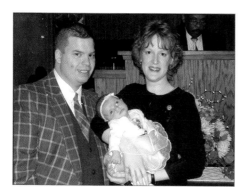

Figure 8.20—
*Parents look proud,
baby looks bored
(and a little limp).*

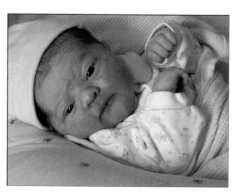

Figure 8.21—*Soft
window light helps
reduce the "little old
man" look of a new-
born.*

If the new baby has older siblings, watch for special moments
between them (see Figure 8.22). Using available light rather
than flash helps you avoid interrupting them, so you can take
several photos until you get the best one.

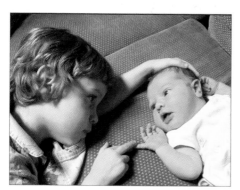

Figure 8.22—
*Big brother, little
sister—a bond
of love.*

BAPTISMS AND CHRISTENINGS

As you remember this special moment, remember that this is a worship experience—meaning that it's time to turn off the flash until after the service is over. To get good photos without flash, get into the front row, change white balance to incandescent or fluorescent as needed, boost the ISO to 400 or above, and be ready to shoot (see Figures 8.23 and 8.24).

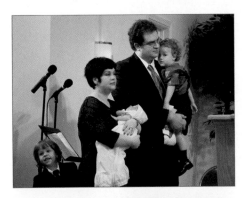

Figure 8.23—*If the whole family's participating, watch for some amusing moments.*

Figure 8.24—*Will she wake up, or won't she?*

REUNIONS AND MEETINGS

Anytime the extended family or friends get together, whether after a wedding, christening, baptism, graduation, or for the holidays, it's a great time to take pictures—after all, you'll never know the next time you'll see those out-of-town friends or relatives.

RESTAURANTS AND DINING

Most people don't like to see photos of the way they eat, so save the camera for before or after the meal itself. If you're getting together in the daytime and the location offers good window light, use it along with Auto white balance (see Figure 8.25) so you don't need to worry about harsh shadows and running down your battery prematurely.

Figure 8.25—
"Reading" a greeting card to mother.

However, if you're shooting photos of the people next to the window, be sure to boost exposure by +0.7–1.0 EV or so to prevent the backlighting from making the picture too dark (see Figure 8.26).

Figure 8.26— +0.7 EV prevents the bright window light from darkening the foreground subject.

Wide-angle (1x) shots like Figure 8.27 help you remember the scene and the people in it. Frame your shots to combine the group (you might need multiple shots to get everyone) and the location.

Figure 8.27—*18mm (1x) zoom captures the group and the decor.*

TIP Having a hard time keeping the camera straight? Use your camera's focusing frames or optional grid display to help shoot straighter shots (Figure 8.27 could use a bit of straightening).

If you're eating after dark, or the restaurant doesn't have good window light, use flash if necessary. If you can't shoot at a 90-degree angle to your subjects, make sure the angle is not too extreme (see Figure 8.28) so the lighting will be fairly even.

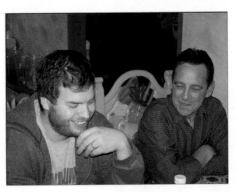

Figure 8.28—*This flash shot is fairly evenly lit because the left subject is only slightly closer to the flash than the right subject.*

INTRODUCTION TO CREATIVE CONTROL MODES

WHY YOU NEED THIS CHAPTER

The difference between casual snapshots and breathtaking photos is as much technical as it is artistic. When you use full Auto mode, the camera controls how each picture is taken; the photos you shoot are the camera's vision of the world. Scene modes provide a limited level of control, but you are still at the mercy of the camera's built-in settings.

The world looks different when you put yourself in charge of your camera's controls—and so will your photos. When you master the creative control modes in this chapter, you're on your way to shooting photos that look better and express how *you* see the world.

BENEFITS OF CREATIVE CONTROL MODES

This chapter discusses creative control modes such as Program (P), Shutter Priority (S, Tv), Aperture Priority (A, Av), and Manual (M) modes. If your camera has a control dial with letters and symbols like the ones shown in Figure 9.1, the letters indicate creative control modes. Note that some cameras call Program mode Auto mode; check the manual for your camera.

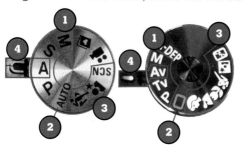

1. Creative Control Modes

2. Full Auto Mode

3. Scene Modes

4. Currently Selected Mode

Figure 9.1—*Typical camera control dials featuring creative control modes.*

Table 9.1 provides a quick reference to each mode.

Table 9.1 Creative Control Modes

Creative Control Mode	Dial Setting	You Control	Camera Controls	Recommended Uses
Program	P	White balance, ISO, other settings	Aperture, shutter speed	General photography
Aperture Priority	A, Av	Aperture, white balance, ISO, other settings	Shutter speed	Portraits, landscapes, macro (ultra close-up)
Shutter Priority	S, Tv	Shutter, white balance, ISO, other settings	Aperture	Fast action, sports, children at play, racing
Manual	M	Shutter and aperture, white balance, ISO, other settings	Nothing	Tricky lighting, night shooting, special effects

BETTER COLORS IN ANY LIGHT

Because you can control the white balance setting when you use creative control modes, you can capture more accurate colors in your photos (see Figures 9.2 and 9.3).

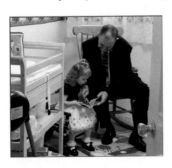

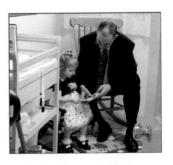

Figure 9.2—*Incorrect white balance produces an overall color cast.*

Figure 9.3—*Correct white balance provides purer color.*

→ *To learn more, see* **Chapter 11**, *"Improving Color."*

JUST-RIGHT EXPOSURES IN TRICKY LIGHTING

Digital cameras don't always know what the best aperture and shutter speed combination should be for a particular picture, and when you use creative control settings, you can override the normal exposure settings, change how the camera measures the light in the scene, or, in manual mode, decide for yourself what shutter speeds and aperture settings to use (see Figures 9.4 and 9.5).

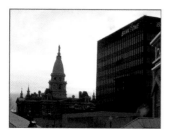

Figure 9.4—*Standard exposure causes backlit subjects to be too dark.*

Figure 9.5— *+1 EV improves lighting on backlit subjects.*

→ To learn more, see "Using Manual Mode," **page 106**, and **Chapter 10**, "Improving Exposure."

CONTROL WHAT'S IN FOCUS

Sometimes you want everything in the picture in focus, and sometimes you want only part of the picture to be sharp. Aperture priority mode enables you to control how much of your picture is in sharp focus.

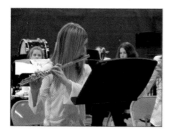

Figure 9.6—*A wide aperture (f/3.6) throws the background out of focus.*

Figure 9.7—*A narrow aperture (f/11) keeps foreground and background in focus.*

→ To learn more, see "Using Aperture Priority Mode," **page 103**, and **Chapter 14**, "Controlling What's in Focus."

CONTROL HOW ACTION IS CAPTURED

Stop a speeding plane in mid flight (see Figure 9.8) or capture the dynamism of a musical performance (see Figure 9.9). When you use shutter priority mode, you control shutter speeds and control how you see life in motion.

Figure 9.8—*A fast shutter speed (1/400 second) stops the stunt plane in mid flight.*

Figure 9.9—*A slow shutter speed (1/46 second) adds a bit of motion blur to show the performers in action.*

→ *To learn more, see "Using Shutter Priority Mode,"* **page 101**, *and* **Chapter 12**, *"Stopping Action."*

CONTROL HOW PHOTOS ARE STORED

Normally, digital cameras store images in JPEG format, but if you want more control over the image, you might prefer to use RAW if your digital camera supports this format (most DSLRs support RAW, but only a few advanced point-and-shoot cameras support RAW). RAW images must be processed by software provided by the camera maker or a third-party company (see Figure 9.10), but RAW images enable you to fine-tune color balance and other settings for better images than with JPEG (see Figure 9.11).

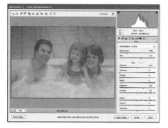 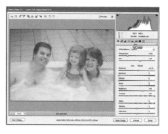

Figure 9.10—*This RAW file has color and contrast problems.*

Figure 9.11—*After adjustment with Adobe Camera RAW for Adobe Photoshop and Photoshop Elements, color and contrast problems are gone.*

You can even shoot with both image types at the same time when you use creative control modes, so you have a JPEG for immediate viewing and a RAW file you can adjust as needed.

NOTE RAW files use much more space per photo than JPEG files, so be prepared to store fewer photos per card. If you shoot in RAW + JPEG, you will be able to store even fewer photos per card. Use 4GB or larger memory cards if your camera can use them, to avoid running out of space as quickly.

→ *To learn more, see "Storing Photos in JPEG Format,"* **page 110**, *and "Storing Photos in RAW Format,"* **page 113**.

USING PROGRAM MODE

Program mode is the easiest creative control mode to use, but because you can adjust white balance, exposure, and image storage settings, you have more control over the picture than you do in full Auto mode, where the camera makes all the decisions regarding white balance, exposure, aperture, ISO, and flash for you. See Chapter 4, "What You Can (and Cannot) Do in Auto Mode," for more about Auto mode.

WHEN TO USE PROGRAM MODE—AND WHY

Use Program mode when precise control of what's in focus (apertures) and how action is captured (shutter speeds) is not important, but the ability to adjust white balance, override normal exposures, and ISO settings is. Compared to full Auto mode, Program mode unlocks advanced camera settings that can make your everyday photos look better. You can override the camera's default settings to get great photos in tricky situations.

HOW PROGRAM MODE WORKS

In Program mode, the camera controls the shutter speed and aperture according to the ISO setting on the camera and the lighting conditions. However, you can adjust the ISO setting, white balance, focus settings, metering settings, and image storage settings as needed to improve your photos.

HOW TO USE PROGRAM MODE

Using Program mode is easy. If your camera has a control dial similar to the one in Figure 9.1, turn it to the P setting. Aim, and take your pictures. View your pictures, and adjust settings if necessary before reshooting your photos.

 NOTE Some cameras that don't offer shutter or aperture priority modes offer an advanced "Manual" mode that acts like Program mode (you can't control shutter speeds or apertures, but you can adjust exposure, white balance, and so on).

PROGRAM MODE PHOTOS

Figures 9.12 and 9.13 illustrate how Program mode helps you make better pictures.

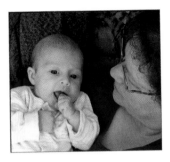

Figure 9.12—*Concentrate on the subject in Program mode and capture those special moments.*

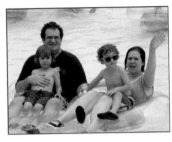

Figure 9.13—*Program mode lets you increase exposure to make up for bright backgrounds (EV adjustment +0.7).*

USING SHUTTER PRIORITY MODE

If action's your game, shutter priority's the name of your favorite creative control mode. You control how quickly the shutter opens and closes, and as a result, you also control how to capture the moving world around you.

WHEN TO USE SHUTTER PRIORITY MODE—AND WHY

Use Shutter Priority mode for fast action, from frolicking children to athletics to race cars. Shutter Priority mode is also helpful for preventing camera shake in dim light because you can select a shutter speed you can hand hold comfortably (meaning you won't get blurry pictures when holding your camera instead of using it on a tripod).

Compared to full Auto or Program mode, Shutter Priority mode makes capturing action easier. Use Table 9.2 to choose a shutter speed that makes sense for your situation.

Table 9.2 Common Shutter Speeds

Shutter Speed Range	Shutter Speed (Seconds)	Some Cameras Display As	Amount of Light Compared to 1/2000	Hand-Held Shooting (3x Zoom or 18–55 Lens)	Recommended Use
Slower to Faster	1/2000	2000	—	Yes	Airplanes, racing, sports (bright sunlight)
	1/1000	1000	2x	Yes	Airplanes, racing, sports (bright sunlight)
	1/500	500	4x	Yes	Children playing, sports (sunny, partly cloudy)
	1/250	250	8x	Yes	Fast action (overcast)
	1/125	125	16x	Yes	Moderate action in daylight; night or indoor action
	1/60	60	32x	Maybe[1]	Indoors; dawn or dusk outdoors
	1/30	30	64x	Maybe[1]	Indoors; dawn or dusk outdoors
	1/15	15	125x	No[2,3]	Indoors; dawn or dusk outdoors
	1/8	8	250x	No[2,3]	Night
	1/4	4	500x	No[2]	Night
	1/2	2	1000x	No[2]	Night
	1	1	2000x	No[2]	Night

[1] Use wide-angle to normal (1–3x) zoom settings to avoid camera shake.

[2] Use a tripod for nonmoving subjects; use flash for moving subjects within flash range.

[3] May be hand-holdable on cameras/lenses with image stabilization (IS) or vibration reduction (VR) feature.

HOW TO USE SHUTTER PRIORITY MODE

Set the control dial or camera menu to S (most cameras) or Tv (Canon cameras), and then use the camera's control wheel or dial to select the shutter speed you want. The camera sets the aperture for you. Take pictures, review the results, and adjust the shutter speed or other settings as needed.

Figures 9.14 and 9.15 illustrate typical camera displays of Shutter Priority mode.

1. Shutter Priority
 Mode Selection

2. Shutter Speed
 Selected By User

Figure 9.14—*The Shutter Priority menu from a Canon digital camera.*

Figure 9.15—*The Shutter Priority menu from a Kodak digital camera.*

If the aperture display blinks or you can't take a picture, the shutter speed is too fast or too slow for a correct exposure. In bright light, choose a faster shutter speed; in dim light, choose a slower shutter speed (refer to Table 9.2).

SHUTTER PRIORITY MODE PHOTOS

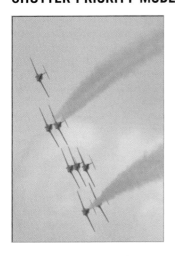

Figure 9.16—*Fast (1/800 second) shutter speed captures jets in mid flight.*

Figure 9.17—*Slow (1/25 second) shutter speed illustrates the fast hand movements needed for juggling.*

USING APERTURE PRIORITY MODE

If portraits, landscapes, or macro (ultra close-up) photography excites you, Aperture Priority should be your favorite creative control mode.

WHEN TO USE APERTURE PRIORITY MODE—AND WHY

Use Aperture Priority mode if you want to control how much of the photo is in sharp focus. When you change the aperture, the depth of field (how much of the photo is in focus) also changes (see Table 9.3).

When you shoot a landscape, you usually want the entire frame to be in sharp focus. However, with portraits or macro photography, you want the subject to be in sharp focus but the background blurred, enabling the viewer to concentrate on the subject. Use Table 9.3 to choose an aperture that makes sense for your situation.

Table 9.3 Common Apertures (f-Stops)

Amount of Light	Aperture	Some Cameras Display As	Amount of Light Compared to f/2.0	Depth of Field	Recommended Use
More to Less	f/1.4	1.4	200%	Extremely shallow	Portraits, dim light shooting
	f/1.8	1.8	133%	Extremely shallow	Portraits, dim light shooting
	f/2.0	2.0	100%	Extremely shallow	Portraits, dim light shooting
	f/2.8	2.8	50%	Shallow	Portraits, dim light shooting
	f/3.5	3.5	33.5%	Shallow	Portraits, dim light shooting
	f/4	4.0	25%	Shallow	Group or individual portraits; general use
	f/4.5	4.5	16.75%	Shallow	Group or individual portraits; general use
	f/5.6	5.6	12.5%	Moderate	General use

Amount of Light	Aperture	Some Cameras Display As	Amount of Light Compared to f/2.0	Depth of Field	Recommended Use
	f/8	8.0	6.25%	Moderate	General use
	f/11	11	3.125%	Deep	General use, landscapes
	f/16	16	1.563%	Deep	General use, landscapes, macro
	f/22	22	0.78%	Deep	Landscapes, macro
	f/32	32	0.39%	Extremely Deep	Landscapes, macro, deep focus
	f/45	45	0.195%	Extremely Deep	Landscapes, macro, deep focus

HOW TO USE APERTURE PRIORITY MODE

Set the control dial or camera menu to A (most cameras) or Av (Canon cameras), and then use the camera's control wheel or dial to select the aperture you want. The camera sets the shutter speed for you. Take pictures, review the results, and adjust the aperture or other settings as needed.

Figures 9.18 and 9.19 illustrate typical camera displays of aperture priority mode.

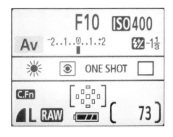

Figure 9.18—*Kodak digital point-and-shoot camera in Aperture Priority mode.*

Figure 9.19—*Canon DSLR camera in Aperture Priority mode.*

If the shutter speed display blinks or you can't take a picture, the aperture is too wide (too much light) or too narrow (not enough light) for a correct exposure. In bright light, choose a narrower aperture (larger number); in dim light, choose a wider aperture (smaller number). Refer to Table 9.3.

APERTURE PRIORITY MODE PHOTOS

Figure 9.20—*Wide (f/2.0) aperture emphasizes main subject.*

1. Moderate (f/5.6) aperture at 3x (55mm) blurs background.

2. Very narrow (f/29) aperture at 3x (55mm) makes background less blurry.

Figure 9.21—*How different aperture settings affect the background.*

USING MANUAL MODE

Manual mode puts you in charge of both aperture and shutter speed—in effect, you become the camera's "brain."

WHEN TO USE MANUAL MODE—AND WHY

Use Manual mode when your camera is baffled by extremely low light, such as night shots, fireworks, and similar situations, or when the camera might be fooled by bright lights or extreme contrasts between the subject and the background.

Manual mode enables you to adjust both aperture and shutter speed to create an exposure combination that works for you in difficult lighting situations. By using Manual mode, which locks the exposure at whatever you set, you can take pictures of your main subject without worrying about extraneous light sources or other issues that might confuse the camera's onboard light meter.

HOW TO USE MANUAL MODE

Before switching to Manual mode, use Program, Aperture Priority, or Shutter Priority and note the approximate shutter and aperture settings to try. To switch to Manual mode, turn the camera control dial to M, or select Manual from the camera menu. Use your camera's control dial or control pad to select an aperture and shutter speed to start with (see your camera manual for details). After taking a couple of photos, review them and adjust aperture or shutter speed as desired.

 TIP Use a tripod for exposures longer than 1/30 second. If you are using a long zoom (4x or above; 70mm or higher on a DSLR), use a tripod at higher shutter speeds. Adjust ISO and white balance as needed for best results.

MANUAL MODE PHOTOS

These photos demonstrate how manual mode helps you get great photos in very low light.

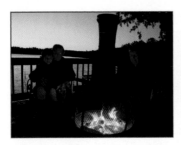

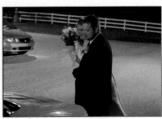

Figure 9.22—*f/5.0, 1/4 second RAW mode (ISO 1600).*

Figure 9.23—*f/2.8, 1/15 second (ISO 1600).*

VIEWING PHOTOS

Whether you're using Full Auto, Scenes, Program, or other modes, getting better pictures depends in large part on viewing your photos as soon as you take them. Knowing how to review your photos for exposure, white balance, and sharpness will help you change the settings needed to improve your photos.

PHOTO VIEWING MODES

Many digital cameras offer two or more viewing modes:

- The standard mode displays your photos in full screen on the camera's LCD display.

- Some cameras offer a second mode that displays the number of shots, the date and time the photo was taken, or basic exposure information along with the photo.

- Some cameras offer a third mode that displays exposure, white balance, and other advanced information, such as a graph of the exposure (histogram), along with the photo.

WHY USE DIFFERENT VIEWING MODES?

The Standard mode lets you know whether you captured the photo you wanted or whether you need to reshoot it. The Exposure Information mode is useful if you want to find out the exposure settings used for the picture. The Advanced Information mode, when available, provides a complete technical overview of the photo.

USING STANDARD VIEWING MODE

To view pictures in the default viewing mode, switch the camera into Viewing mode. Depending on the camera, you might push a VCR or DVD player-style Play button, slide a switch from Camera (shooting) to Play mode, or press a button called Review. Figure 9.24 illustrates a typical example.

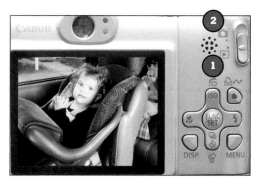

1. Viewing Mode Selected

2. Shooting Mode

Figure 9.24—*Using the playback control to review a photo. Standard mode (seen here) does not display exposure information.*

VIEWING PHOTOS IN OTHER MODES

To change viewing modes, press the Information or Display button while viewing a photo in Standard mode (refer to Figure 9.24). Press this button again until the desired viewing mode appears.

Figures 9.25 and 9.26 compare advanced viewing modes used by Canon A580 and Kodak Z612 IS cameras. Other cameras use similar displays.

→ *For more information about histograms, see the section "Improving Exposure in Histogram View,"* **page 125**.

→ *For more information about white balance, see* **Chapter 11**, *"Improving Color."*

→ *For more information about image size and quality settings, see "Storing Photos in JPEG Format,"* **page 110**.

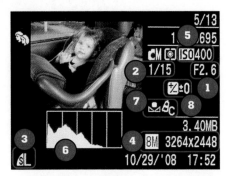

1. Aperture
2. Shutter Speed
3. Resolution and Image/Compression Quality
4. Image Size (Megapixel/Actual Pixels)
5. ISO
6. Histogram of Photo
7. White Balance
8. EV/AV Adjustment

Figure 9.25—*Canon A580*.

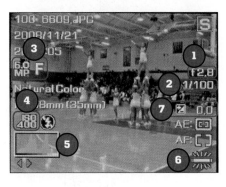

1. Aperture
2. Shutter Speed
3. Resolution and Image/Compression Quality
4. ISO
5. Histogram of Photo
6. White Balance
7. EV/AV Adjustment

Figure 9.26—*Kodak Z612 IS*.

STORING PHOTOS IN JPEG FORMAT

By default, digital cameras store photos in JPEG (.jpg) format. However, the choices you make in image size and quality can help you make the best quality photos, or can trade reduced image quality for more pictures per card. I'm a big believer in maximum image quality, but regardless of your choices, here's how you set your camera.

WHEN TO USE JPEG FORMAT—AND WHY

Use JPEG format if it's the only format supported by your digital camera. However, if your digital camera also supports RAW, use RAW + JPEG to get all the advantages of RAW format and the convenience of JPEG.

TIP RAW files use much more space than JPEG files, and RAW + JPEG use the most of all. If you don't want to shoot in RAW + JPEG mode but want JPEG files for convenience, you can convert RAW files to JPEG files with many popular photo editors.

Using JPEG format ensures that your pictures are ready to upload for printing and viewing on your computer or TV and are ready to resize for email and web use. You can use your photos as soon as you transfer your photos to the computer.

SELECTING JPEG SIZE SETTINGS

Digital cameras offer several smaller JPEG image sizes in addition to the maximum JPEG image size. JPEG size settings are usually made from the camera's shooting setup menu (often symbolized with a camera icon). Depending on the camera, you press the Menu button or the Func Set button to open the menu. JPEG size settings might be listed by megapixel rating (MP), dimensions in horizontal and vertical pixels, or by size (small, medium, large).

If you select a smaller image size than your camera's maximum, you can shoot more pictures before your camera storage fills up, but the quality of each image will be lower (see Figure 9.27).

NOTE Here's how you calculate the megapixel (MP) rating: Multiply the number of horizontal pixels in the image by vertical pixels, and divide by 1 million. For example, a camera with a resolution of 2832×2128 pixels is a 6MP camera. $2832 \times 2128 = 6,026,496$. $6026496/1,000,000 = 6.026MP$.

SELECTING QUALITY SETTINGS

The vast majority of digital cameras include two or more quality settings, also set from the camera's shooting setup menu. Terminology differs by camera, but some examples include Normal, Fine, and SuperFine (SuperFine is best); Basic, Normal, Fine (Fine is best); and Normal, High Quality (HQ), and Super High Quality (SHQ is best). Some

cameras have separate image size settings for normal and best quality.

Choosing the highest image quality compresses the image less than other settings, which means you store fewer photos per card. However, fine details in your photos look better with less compression (see Figure 9.28).

COMPARING JPEG IMAGE SIZE AND QUALITY SETTINGS

Figure 9.27 compares the same scene in 10MP and 2.5MP resolutions at best quality. Note that the 10MP image is sharper than the 2.5MP image when scaled to the same size.

1. 2.5MP

2. 10MP

3. Fuzzier Detail

4. Sharper Detail

Figure 9.27—*Comparing 2.5MP and 10MP versions of the same subject.*

Figure 9.28 compares the same scene in superfine (highest) and normal (lowest) quality. Note that the superfine image is sharper than the normal image and has a less blocky appearance.

1. Basic (Lowest) Quality

2. Superfine (Highest) Quality

3. Blocky Colors and Lumpy Shapes

4. Smooth Colors and Crisp Shapes

Figure 9.28—*Even at the camera's highest resolution, superfine produces sharper results than basic quality.*

STORING PHOTOS IN RAW FORMAT

Most DSLR cameras, and some high-end point-and-shoot digital cameras, offer another type of image storage: RAW format. Here's what you need to know about RAW format and why you might prefer to use it.

WHEN TO USE RAW FORMAT—AND WHY

Use RAW format when you need maximum image quality and maximum control over the photo after you shoot it—and when you have large enough storage to handle the extra size of each RAW image. I recommend 4GB or larger memory cards.

RAW format stores all the image data that the camera sensor captures during the photo shoot. By contrast, JPEG discards data as white balance, image/sharpness, color mode, and other settings are applied. Thus, a JPEG file could be said to be "precooked" to a particular recipe by your camera's settings, while a RAW file provides all the information (or ingredients) necessary for the photo. You must process, or "cook," the photo yourself using software provided by the camera vendor or third-party software such as Adobe Camera RAW.

So RAW files are much larger than JPEG files, but because RAW files do not discard information, the results are sharper photos (see Figure 9.29) and a much greater capability to correct color and exposure problems than with JPEG (refer to Figures 9.10 and 9.11).

Keep in mind, though, that because each camera manufacturer has its own version of the RAW format (and even different RAW formats for different model cameras) you might need to install a software program known as a codec from your camera manufacturer to view RAW files from your model camera in your operating system (Windows Vista, Windows 7, and Mac OS X provide better RAW image support than Windows XP). And, you will still need to "process" RAW images with software provided by the camera manufacturer or a third party before you can convert them to JPEG, print them, or use them in other ways.

HOW TO USE RAW FORMAT

If your camera offers RAW format, select it from the same menu where you select JPEG image size. For convenience, I recommend shooting RAW + JPEG, so you always have a thumbnail image visible in your operating system, you have an image you can print or email right away, and you have a better quality image you can edit. RAW is generally available only in the camera's maximum image size.

RAW FORMAT PHOTOS

Figure 9.29 compares a basketball photo captured in RAW and best-quality JPEG versions. Note that the RAW version is sharper and has more accurate color.

1. RAW
2. Best Quality JPEG
3. Sharper Detail
4. Fuzzier Detail
5. Purer Colors
6. Distorted Colors

Figure 9.29—*A side-by-side comparison of the same shot stored in RAW + JPEG Best Quality formats.*

 # IMPROVING EXPOSURE

WHY YOU NEED THIS CHAPTER

Want to avoid making excuses for your photos? Want to avoid spending hours with Picasa, Adobe Photoshop Elements, or other photo editors? Make sure your photos are well exposed: not too dark, and especially not too light.

Although today's digital cameras have standard onboard light meters and automatic exposure controls, tricky lighting situations, such as backlit subjects or dark or light backgrounds, can fool your camera into producing pictures you don't want to show friends and family. As a bonus, well-exposed pictures usually have better color and contrast than pictures that are too dark or too light, so you won't need to spend hours editing your pictures.

Your first step, as always, is to take a test picture and immediately look at it in your digital camera's LCD display. Use your camera's playback feature if necessary, but look it over before you take more pictures. You might be perfectly happy with the results, but if the subject is too dark or too light, you've come to the right place for help.

How Cameras Determine the "Correct" Exposure

If digital cameras contain very sophisticated light measurement systems, why would you ever need to override what the camera says is the "correct" exposure? Here's why: The light meters used in both film and digital cameras are designed to provide proper exposure of a subject with an 18% reflective value—in simple language, medium gray.

In the real world, seldom is a photo taken of medium gray subjects, but most photos include a mix of light and dark areas so that the camera's assumption of medium gray provides a good exposure. However, when the background is much lighter (backlit subject, snow or beach scene) or much darker (spotlit subject, dark sky or dark wall background) than medium gray, cameras produce results that are too dark or too light. And that's when you need to give your camera some help to get better photos.

USING EXPOSURE LOCK

No matter how advanced or how simple a digital camera you use, you probably can use Exposure Lock to help get a better-exposed picture. You don't need to open a menu to use it, either.

WHEN TO USE EXPOSURE LOCK—AND WHY

Use Exposure Lock when your subject is in front of a background that is much brighter or darker than the subject itself—for example, if your subject is in front of a window, in the spotlight on the stage, or outdoors with the sky as a background. Exposure Lock is also the perfect method to use for better pictures if you are shooting an off-center subject.

Using Exposure Lock helps you get better pictures because you control what the camera "looks at" to decide how to expose the scene. Exposure Lock is a feature of almost all digital cameras, from low-end auto-only models to the most expensive digital SLR models, so it's a technique you can use with almost any camera. And it works the same way on almost all cameras.

HOW EXPOSURE LOCK WORKS

Here's how it works:

1. Aim the camera at what you want to meter.
2. Press the shutter button down halfway and hold it.
3. Frame your picture the way you want it.
4. Press the shutter button down the rest of the way to take the picture.

 NOTE On almost all cameras, Exposure Lock also locks in the focus. So remember: You're locking in the exposure *and* the focus.

HOW TO USE EXPOSURE LOCK

If your subject is in front of a light or dark background, aim at his or her feet, lock in the exposure (and the focus), frame the subject as desired, and shoot.

If your subject is off to one side of the center, point your camera at the subject, lock in the exposure, frame the subject as desired (off-center subjects are more interesting than centered subjects), and shoot.

Figure 10.1 illustrates how to use Exposure Lock to prevent a bright sky background from ruining a picture of a building.

1. Aim the camera at the shaded side and use Exposure Lock.

2. After locking the exposure, aim the camera as desired.

Figure 10.1—*Aim at the side of the building away from the bright sky background, and then lock the exposure.*

BEFORE AND AFTER EXPOSURE LOCK

Figure 10.2 is a typical photo of a building against a bright sky. The bright sky throws off the exposure, making the building too dark.

Figure 10.3 shows the same building after using Exposure Lock. By aiming at the side of the building away from the sky and locking in the exposure, you can now see detail on the side of the building.

Figure 10.2—*The side of the building is too dark without Exposure Lock.*

Figure 10.3—*The side of the building is properly exposed with Exposure Lock.*

USING EV ADJUSTMENT

Although Exposure Lock is a quick and easy way to improve exposure, it isn't always possible. When a light or dark background confuses your camera and you can't find a way to meter the subject without the background getting in the way, EV Adjustment is your friend.

Cameras that feature EV Adjustment generally have a button or menu option marked with the EV Adjustment (sometimes called AV Adjustment or Exposure Bias) symbol shown in Figure 10.4.

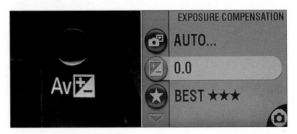

Figure 10.4—*Examples of EV Adjustment button (left) and menu (right) controls.*

WHEN TO USE EV ADJUSTMENT—AND WHY

Use EV Adjustment to override the normal exposure the camera uses to take a picture. When the background is much darker or lighter than the subject, and you can't use Exposure Lock, you can use EV Adjustment to get the right exposure for your subject.

 NOTE EV Adjustment will not work in Full Auto mode. Use Program, Shutter Priority, Aperture Priority, or other camera settings that enable you to override the camera's normal exposure settings.

EV Adjustment enables you to fine-tune how much more (or less) exposure to use in your photos. You don't need to reframe the subject, either. You can frame the picture the way you want and use EV Adjustment to increase or decrease the exposure.

HOW EV ADJUSTMENT WORKS

EV Adjustment adjusts exposure in steps of one-half or one-third EV (it varies by camera). +1 EV doubles the exposure, whereas −1 EV cuts the exposure in half. Cameras allow EV Adjustment up to +2/−2 EV, so you have a lot of options for fine-tuning the exposure.

If your camera is set for Program mode (the camera sets the shutter speed and aperture for you), the camera will adjust both shutter speed and aperture to make the adjustment. If the camera is set for Shutter Priority mode, the camera will adjust the aperture to make the adjustment. If the camera is set for Aperture Priority, the camera will adjust the shutter speed.

→ *To learn more about Shutter and Aperture Priority settings, see **Chapter 9**, "Introduction to Creative Control Modes."*

HOW TO USE EV ADJUSTMENT

1. Press the EV Adjustment button or open the EV Adjustment menu.
2. Select an appropriate adjustment: If the background is lighter than the subject, try +1 EV; if the background is darker than the subject, try −1 EV.

3. Take the picture. Fine-tune the EV setting as needed for best results.

Some cameras show the complete EV Adjustment scale, while others show only the selected value. See Figure 10.5 for typical examples.

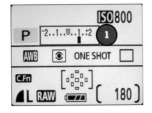

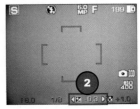

1. +1 EV

2. -0.3 EV

Figure 10.5—*EV adjustments.*

BEFORE AND AFTER EV ADJUSTMENT

In Figure 10.6, the bright sky behind the subject makes the subject too dark with "normal" (0 EV) exposure. Figure 10.7 shows the same subject moments later after enabling +1 EV. The subject is now properly exposed.

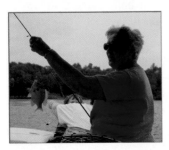

Figure 10.6—*Normal (0 EV) exposure.*

Figure 10.7—*+1 EV provides the proper exposure for the main subject.*

USING SPOT METERING

Most digital cameras meter the entire frame when setting the exposure. However, some cameras include an alternative metering method called spot metering that measures only the light in the center of the frame. If your camera features a spot metering setting, you can use it to set the exposure for the most important part of the photo.

WHEN TO USE SPOT METERING

Use spot metering to set the subject's brightness when the background is much brighter or darker than the subject, especially if the subject is a relatively small part of the picture. Spot metering is especially helpful in dealing with stage lighting or subjects against an open sky.

WHY USE SPOT METERING?

Use spot metering to get the best exposure for the subject without needing to shoot a series of pictures using different EV values.

HOW TO USE SPOT METERING

1. Open the metering mode menu and select Spot Metering (see Figure 10.8).

2. Point the camera at the subject and center the frame on the most important part of the subject. Some cameras might display a circle or pip in the middle of the frame when spot metering is enabled.

3. Press the shutter button down partway, and hold it to lock the exposure.

4. Reframe the picture as desired and shoot when you're ready.

1. Select spot metering.

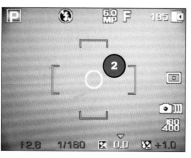

2. The mark in the middle of the frame shows that spot metering is enabled.

Figure 10.8—*Selecting and using spot metering.*

BEFORE AND AFTER SPOT METERING

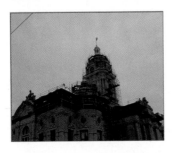 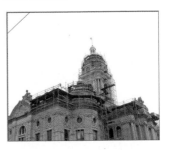

Figure 10.9—*Center weighted averaging (a typical metering mode in many cameras) makes the building too dark.*

Figure 10.10—*Spot metering the building provides the best exposure.*

USING ISO ADJUSTMENTS

Film cameras use different ISO film speeds for different lighting situations: ISO 100–200 for bright light and flash, ISO 400 for dim light and longer flash range, and ISO 800 for action shooting in dim light. Digital cameras use the ISO setting the same way. The normal ISO setting for most digital cameras is Auto, which in practice works out to approximately ISO 80–250 (depending upon the camera).

WHEN TO USE ISO ADJUSTMENTS

Auto ISO works great when you're outdoors at noon or taking a flash picture of somebody who's just a few feet away. However, when you need to shoot indoors without flash, or it's a dark day, or you need to stop action, you need a higher ISO setting.

WHY USE ISO ADJUSTMENTS?

A higher ISO setting (400 or higher) enables you to shoot flash pictures a little farther away, use a faster shutter speed to stop action or prevent camera shake, shoot in dim light without flash, or use a narrower aperture to increase depth of field.

Selecting a low ISO (such as ISO 80–100) enables you to use flash at close range without burning out the subject, use a wider aperture to blur the background, or use a slower shutter speed for creative effects such as motion blur or moving water blur.

HOW TO USE ISO ADJUSTMENTS

Some cameras have a dedicated button for ISO adjustments, but most use a menu setting for ISO adjustments.

1. Press the ISO button, or open the menu and go to the ISO settings menu.
2. Select the ISO value you want to use.
3. Take pictures.

BEFORE AND AFTER ISO ADJUSTMENTS

Figure 10.11—*Auto mode uses flash at this nighttime street fair, ruining the mood.*

Figure 10.12—*High ISO enables you to shoot without flash, keeping the mood.*

DON'T USE TOO HIGH AN ISO SETTING

The latest compact digital cameras feature ISO settings up to 1600, and some digital SLRs have ISO settings up to 3200. What happens if you use the highest ISO your camera offers? You might not like the results. Compare these snapshots taken the same day just a few hours apart using a compact digital camera (Canon A580). Figure 10.13 was shot using ISO 400, whereas Figure 10.14 used ISO 1600. It looks as if the ISO 1600 photo was printed on sandpaper!

1. Smooth
Skin Tones

Figure 10.13—*ISO 400 produces very good results with both point-and-shoot and DSLR cameras.*

1. Digital
Image "Noise"

Figure 10.14—*Using ISO 1600 on a compact point-and-shoot camera produces a very low-quality photo compared to ISO 400 or even ISO 800.*

Compact point-and-shoot cameras have very small image sensors. When you shoot photos at ISO 800–1600 or above, you will see a lot of digital image "noise" (small color flecks and blotches). Digital SLRs do better at high ISOs because they have larger image sensors. However, you should use the lowest

ISO setting that you can. For compact point-and-shoot cameras, I recommend ISO 400 as the highest setting for maximum picture quality. For digital SLR cameras, I recommend ISO 800 as the highest setting for maximum picture quality.

If you want to use higher ISO settings, do some test shooting at each ISO setting before you shoot any irreplaceable photos. With most compact point-and-shoot cameras, ISO 800 produces results that are much better than ISO 1600, and in retrospect, that's what I should have used when the light got dim.

IMPROVING EXPOSURE IN HISTOGRAM VIEW

Most digital cameras offer a Histogram view as a playback option. To switch to the Histogram view, press the Display or Information button while viewing the photo. A *histogram* is a graphical representation of the exposure information in the photo. A properly exposed photo has a histogram that extends across the graph from left (darkest parts of the photo) to right (lightest parts of the photo), as in Figure 10.15. By contrast, the histogram for an underexposed photo (Figure 10.16) displays primarily (or exclusively) exposure data for the left side of the graph, and the histogram for an overexposed photo (Figure 10.17) displays exposure data for the middle (midtones) and right (light tones) portions of the graph only.

→ See "Photo Viewing Modes," **page 108**, to learn how to access photo viewing and playback.

1. Histogram of a Properly Exposed Photo

Figure 10.15—*A properly exposed photo in Histogram view.*

1. Histogram of an Underexposed Photo

Figure 10.16—*An underexposed (too dark) photo in Histogram view.*

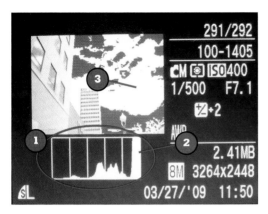

1. Histogram of an Overexposed Photo

2. Clipped Exposure Information

3. Blinking Indicates Overexposed Areas of Photo

Figure 10.17—*An overexposed (too light) photo in Histogram view.*

When you can't see the top of an exposure "peak," as in Figures 10.16 and 10.17, the exposure information has been clipped—the photo is too dark or too light to capture the darkest or lightest exposure information. Many cameras blink the overexposed (clipped) parts of the photo (refer to Figure 10.17). To solve exposure problems, refer to Chapters 1 and 9.

IMPROVING COLOR

WHY YOU NEED THIS CHAPTER

It's easy to shoot pictures with poor color but hard to fix them afterward. Although today's photo editing programs provide better color-correction tools than ever before, you can avoid hours of tedious color repair processes by using your camera's white balance and color settings features.

If your camera can use filters (all digital SLR and some point-and-shoot cameras can), you can improve the color quality of your photos even more.

Your first step, as always, is to take a picture and review it on your camera's LCD display. You might be perfectly happy with the results, but if your photos are being spoiled by color problems, this chapter is here to help.

WHY USE WHITE BALANCE SETTINGS?

The human eye is very good at seeing accurate colors in any light, but digital cameras aren't nearly as intelligent. The white balance settings in digital cameras help the camera compensate for differences in the color of light so that your pictures have accurate color in any light.

Most digital cameras include the following white balance settings:

- **Auto**—The default setting for most cameras.

- **Daylight**—Use in sunny to partly cloudy situations.

- **Fluorescent**—Use when shooting under tube or CFL lighting; some cameras offer two or more fluorescent settings.

- **Tungsten/Incandescent**—Use when shooting under traditional light bulb, fireplace, or campfire lighting.

- **Electronic Flash**—Use when shooting with onboard or add-on electronic flash. If not available, use Auto or Daylight.

- **Cloudy or Open Shade**—Use under overcast skies or when the subject is in the shade. Some cameras offer separate Cloudy and Open Shade settings.

Most DSLR cameras (as well as a few high-end point-and-shoot cameras) also include custom white balance as another option.

As you can see from the photo montage in Figure 11.1, using the wrong white balance setting can really foul up your photos.

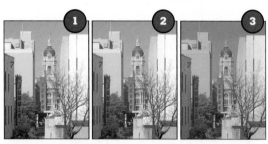

1. Auto

2. Daylight

3. Tungsten/ Incandescent

4 Fluorescent

5. Cloudy

Figure 11.1—You can see the difference between the white balance settings.

AWB By default, digital cameras use auto white balance (WB). Auto white balance works quite well in midday light or when electronic flash is used, but it has three big limitations: Because auto white balance tries to adjust the white balance dynamically with each shot, it can select the wrong setting;

auto WB can't cope with extremely yellow light (such as from incandescent light bulbs) or extremely blue light (such as on a cloudy or overcast day); photos shot with Auto WB have less vivid colors than those shot with the correct preset or custom white balance setting.

When you shoot in full auto mode, the camera uses auto white balance. You can use auto white balance in other modes, but you'll get better color if you match a preset white balance setting to your current lighting conditions. You'll get the best color of all if you choose custom white balance.

 TIP Sometimes it can be difficult to decide what the best white balance setting is, especially if you're shooting inside public buildings. Try different white balance settings as in Figure 11.1, and use the setting that looks best, or, if you can get access to the area where your subjects will be, use custom white balance.

HOW TO CHANGE WHITE BALANCE SETTINGS

Some cameras feature a dedicated white balance button that opens the white balance menu immediately, while others require you to open a shooting menu and select the white balance setting desired. Figure 11.2 illustrates some typical white balance menus. To use white balance settings other than auto, you must switch your camera from Full Auto to any other advanced shooting mode: Program, Shutter Priority, Aperture Priority, or Manual modes. You can then select the white balance you prefer.

USING DAYLIGHT WHITE BALANCE

Although the differences between pictures taken with auto white balance and daylight white balance can be subtle, daylight white balance doesn't try to outguess the white balance in a scene. Instead, it assumes the photo is being lit by daylight.

WHEN TO USE DAYLIGHT WHITE BALANCE—AND WHY

Use daylight white balance when you're shooting in daylight or with electronic flash (unless your camera has a separate

electronic flash white balance setting). It's simple: Use daylight white balance anytime between dawn and dusk if the sky's not overcast. Because daylight white balance doesn't shift white balance settings in response to the colors in a photo, it provides more accurate and more vivid colors than auto white balance.

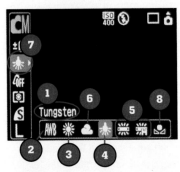

1. Current White Balance Setting
2. Auto
3. Daylight
4. Tungsten/Incandescent
5. Fluorescent
6. Cloudy
7. Electronic Flash
8. Custom

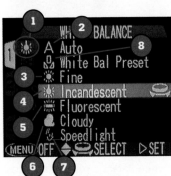

1. Current White Balance Setting
2. Auto
3. Daylight
4. Tungsten/Incandescent
5. Fluorescent
6. Cloudy
7. Electronic Flash
8. Custom

Figure 11.2—*Some typical white balance menus.*

HOW TO USE DAYLIGHT WHITE BALANCE

If necessary, switch your camera from full auto into an advanced shooting mode (Program, Shutter Priority, Aperture Priority, or Manual). Then, select daylight WB from the white balance menu and take your photos.

BEFORE AND AFTER DAYLIGHT WHITE BALANCE

Figures 11.3 and 11.4 show the same scene shot with auto white balance (Figure 11.3) and daylight white balance

(Figure 11.4). Figure 11.4 has more vivid and accurate colors than Figure 11.3.

Figure 11.3—*Auto white balance has subdued color in daylight.*

Figure 11.4—*Better color with daylight white balance.*

USING INCANDESCENT WHITE BALANCE

Compared to daylight, incandescent light bulbs produce a very yellow light, and if you use auto or daylight white balance when you're taking pictures under incandescent light (also known as tungsten light because of the filament in the bulbs), you'll have a yellow or orange cast over your photos.

Incandescent (tungsten) white balance enables you to take pictures with good color when these light sources are in use.

WHEN TO USE INCANDESCENT WHITE BALANCE— AND WHY

Use incandescent (tungsten) white balance whenever incandescent lighting is used, such as in home interiors or on stage shows.

CAUTION Compact fluorescent lights (CFLs) are replacing incandescent lights in many homes. These typically produce a less yellow light than incandescent bulbs. Use fluorescent or custom white balance settings for these bulbs. CFLs usually use a twisted tube design instead of the smooth globe used by incandescent bulbs.

Incandescent (tungsten) white balance provides more accurate color and prevents the overall yellow or orange color cast that results from shooting indoors with daylight or auto color balance settings.

HOW TO USE INCANDESCENT WHITE BALANCE

If necessary, switch your camera from full auto to an advanced shooting mode (Program, Shutter Priority, Aperture Priority, or Manual). Then, select incandescent or tungsten WB from the white balance menu and take your photos.

BEFORE AND AFTER INCANDESCENT WHITE BALANCE

Figures 11.5 and 11.6 compare a stage show shot with auto white balance (Figure 11.5) and incandescent (tungsten) white balance (Figure 11.6). Note how using incandescent white balance removes the orange cast caused by the stage lighting. The result: more accurate colors and whiter whites.

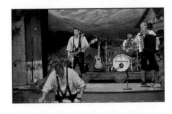

Figure 11.5—*Auto white balance creates an orange color cast under stage lighting.*

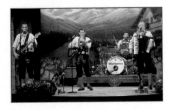

Figure 11.6—*Better color with incandescent (tungsten) white balance.*

USING FLUORESCENT WHITE BALANCE

While "old-school" greenish tubes are still found in some locations, more recent designs in both tube and CFL forms are available in warm white (not as yellow as tungsten/incandescent light), daylight, or cool white (between cloudy and open shade bluish light) versions. It's no wonder that many recent digital cameras offer two or more fluorescent white balance settings for the warmer and cooler types of fluorescent bulbs.

WHEN TO USE FLUORESCENT WHITE BALANCE— AND WHY

Use a fluorescent white balance when shooting under fluorescent lights. You might also encounter mercury vapor or sodium vapor lights in public buildings, at home, or outdoors. If your camera offers you a choice of fluorescent white balance settings, choose the cool daylight fluorescent setting for mercury vapor lights. For sodium vapor lights, choose the warm white fluorescent setting. If your camera doesn't offer you the choice, follow the instructions in this chapter for creating a custom white balance, or take test shots with various white balance settings and choose the one that provides the most accurate colors.

Fluorescent white balance provides more accurate color than daylight or incandescent white balance under fluorescent or similar light, avoiding problems with faded or too-yellow colors that can occur with other white balance settings.

HOW TO USE FLUORESCENT WHITE BALANCE

If necessary, switch your camera from full auto to an advanced shooting mode (Program, Shutter Priority, Aperture Priority, or Manual). Then, select fluorescent white balance from the white balance menu and take your photos. If the camera offers two or more fluorescent white balance settings, try all of them, review them, and decide which setting produces the most accurate color.

BEFORE AND AFTER FLUORESCENT WHITE BALANCE

Figures 11.7 and 11.8 compare photos taken within moments of each other with daylight (Figure 11.7) and fluorescent (Figure 11.8) white balance.

USING CLOUDY/OPEN SHADE WHITE BALANCE

If you're shooting in the daytime but the sun is blocked by clouds or your subject is in the shadow of a building but is being lit by the sky, the light hitting your subject is bluer ("colder") than daylight.

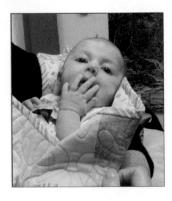 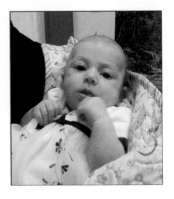

Figure 11.7—*Daylight white balance under fluorescent light makes skin tones too ruddy.*

Figure 11.8—*Better color with fluorescent white balance.*

WHEN TO USE CLOUDY/OPEN SHADE WHITE BALANCE—AND WHY

Use cloudy white balance when colors are too blue on an overcast day. Or use it when you're shooting in open shade if the camera doesn't have an open shade setting. Use open shade when the subject is lit by the sky but is not in direct sunlight.

Cloudy and open shade white balance settings counteract bluish light and help create more natural-looking colors. Some cameras offer separate settings for cloudy and open shade, while others offer only a cloudy white balance setting. When present, the open shade white balance has a stronger warming effect than the cloudy white balance setting.

HOW TO USE CLOUDY/OPEN SHADE WHITE BALANCE

 If necessary, switch your camera from full auto to an advanced shooting mode (Program, Shutter Priority, Aperture Priority, or Manual). To shoot on a cloudy day, select cloudy white balance from the white balance menu and take your photos.

If the camera includes an open shade white balance setting, use it if the cloudy white balance setting produces colors that are too bluish ("cold").

COMPARING DAYLIGHT, CLOUDY, AND OPEN SHADE WHITE BALANCE

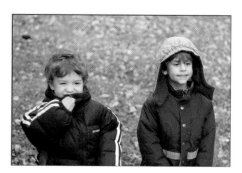

Figure 11.9—
Daylight white balance produces colors that are too bluish ("cold") on a very overcast day.

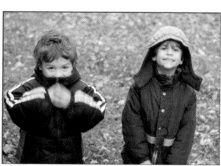

Figure 11.10—
Cloudy white balance "warms" the colors, but sometimes not enough.

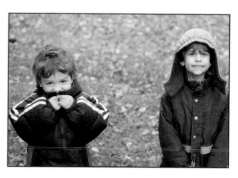

Figure 11.11—*Open shade white balance provides natural colors on a very overcast day.*

USING CUSTOM WHITE BALANCE

Custom white balance enables you to create a white balance setting that exactly matches the light hitting the subject.

WHEN TO USE CUSTOM WHITE BALANCE—AND WHY

Use custom white balance if you are not satisfied with any of the preset white balance settings (this can happen with mixed light sources) *and* if you can get close enough to the subject to place a white or 18% neutral gray card in the light hitting the subject; this card will be used to set up custom white balance. You can use a white index card or sheet of paper, but for better accuracy, use an 18% neutral gray card that you can buy from a camera store. If you set custom white balance properly, the color accuracy will be much better than with the closest preset white balance setting.

HOW TO USE CUSTOM WHITE BALANCE

If necessary, switch your camera from full auto to an advanced shooting mode (Program, Shutter Priority, Aperture Priority, or Manual). Place a white card or 18% neutral gray card under the light hitting the subject.

Nikon models can measure custom white balance from the card or from a photo of the card.

Olympus models can measure custom white balance from the card.

Canon models must take a photo of the card, and then use the photo to set custom white balance. See your camera's instruction manual to determine whether it supports custom white balance and for setup details.

BEFORE AND AFTER CUSTOM WHITE BALANCE

Figures 11.12 and 11.13 compare preset and custom white balance settings under fluorescent light.

USING COLOR SETTINGS

If the colors in your photo are too intense or too dull, most digital cameras enable you to intensify or reduce them, or even eliminate them entirely.

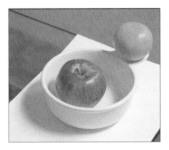

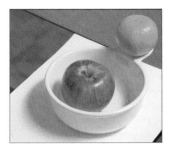

Figure 11.12—*This still life has a slight warm color cast when fluorescent white balance is used.*

Figure 11.13—*By using custom white balance measured from the light hitting the scene, all the colors are accurate and vivid.*

WHEN TO USE COLOR SETTINGS—AND WHY

Use color settings to provide alternatives to the way you normally photograph a scene or an event. As you can see from Figure 11.14, different color settings change how a scene looks. Use vivid (high color) to intensify colors, such as autumn leaves or sports team uniforms. Use neutral if the colors in your shots are overpowering. Use special effects, such as sepia or black and white, to create an "old-fashioned" look for your photos.

HOW TO USE COLOR SETTINGS

If necessary, switch your camera from full auto to an advanced shooting mode (Program, Shutter Priority, Aperture Priority, or Manual). Open the shooting menu and select the color menu (see your camera's instruction manual for details). Shoot a couple of photos using the normal color setting then try other settings and compare them.

COLOR SETTINGS COMPARED

As Figure 11.14 shows, you can drastically affect the look of your photos by selecting different color settings.

1. Normal

2. Vivid
(High Colo

3. Sepia

4. Black and
White

Figure 11.14—*The same scene photographed with a variety of color settings.*

STOPPING ACTION

WHY YOU NEED THIS CHAPTER

Using the right shutter speed for the subject can transform snap-shots into great photos and help prevent camera shake, which turns potentially beautiful photos into digital mush. In this chapter, you'll learn how to choose the best shutter speeds for your favorite subjects, how to avoid camera shake, how to suggest movement with special shooting methods (Figure 12.1), and how to capture action even in dim light (Figure 12.2).

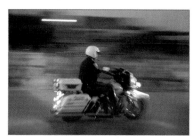

Figure 12.1—*Panning the camera while shooting provides a fairly sharp photo of the main subject while it streaks the background (1/6 second, f/2.6, ISO 400).*

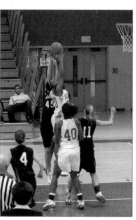

Figure 12.2—*Shooting at the peak of action stops the jumpers perfectly (1/125 second, f/4.0, ISO 1600).*

SHUTTER SPEEDS 101

Whether your camera is set to Shutter Priority (you set the shutter speed, the camera sets the aperture), Aperture Priority

(you set the aperture, the camera sets the shutter speed), or Full Auto or Program modes (the camera sets both), you must deal with these inescapable truths about shutter speeds:

■ A shutter speed that's too slow for the action causes motion blur in your subject (see Figure 12.3).

■ A shutter speed that's too slow for you to hand-hold the camera steady can cause camera shake (see Figure 12.4).

■ The longer the lens or greater the zoom setting, the faster a shutter speed you need to prevent camera shake.

■ Wider apertures (f/1.8 through f/4.0) permit faster shutter speeds than narrower apertures (f/5.6 through f/45).

■ If you can't shoot at a fast enough shutter speed to avoid camera shake or stop action, you can increase the ISO setting. Keep in mind that using your camera's highest ISO settings (800 or higher with point and shoot; 1600 or higher with DSLR cameras) causes the photo to appear grainy, noisy, and less sharp than photos shot at lower ISO ratings.

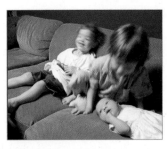

Figure 12.3—*Excessive motion blur caused by 1/10-second shutter speed.*

Figure 12.4—*Camera shake caused by 0.6-second shutter speed.*

AVOIDING CAMERA SHAKE

If you're not using a tripod, monopod, or a camera/lens that features image stabilization (see Chapter 14, "Controlling What's in Focus"), you must watch out for camera shake (refer to Figure 12.4).

How can you avoid camera shake? Use shutter speeds in the following ranges. Note that the longer the lens or the higher the zoom factor, the faster the shutter speed is needed to prevent camera shake.

- Up to 4x/70mm: 1/60 second or faster

- 4x–8x/70–150mm: 1/125 second or faster

- 8x–12x/150–200mm: 1/250 second or faster

- Above 12x/200–300mm: 1/500 second or faster

→ *How does image stabilization help prevent camera shake? See "Using Anti-Shake Technologies," **page 196**.*

→ *Confused about apertures? See "Using Aperture Priority Mode," **page 103**.*

→ *Need more information about shutter speeds? See "Using Shutter Priority Mode," **page 101**.*

SELECTING THE "RIGHT" SHUTTER SPEED

The right shutter speed for any photo is a matter of debate. However, more than 30 years of experience in photography helps me make some informed suggestions. Keep in mind that the right shutter speed is the one that helps you get the photo you want. If you want to stop action completely, Figure 12.5 shows you that the direction of movement across the shot affects the shutter speed you need to use. Figure 12.5 assumes a 1x–4x zoom lens at distances of 15 feet or more from your subject and should be used as a general guide. A fast-moving subject that is very close or is being photographed with a longer zoom lens may require a faster shutter speed.

For maximum control over shutter speed, use Shutter Priority mode. If your camera does not feature Shutter Priority mode, increase the ISO to get faster shutter speeds, decrease the ISO to get slower shutter speeds, or use action-oriented scene modes, such as Sports, Kids and Pets, and so on.

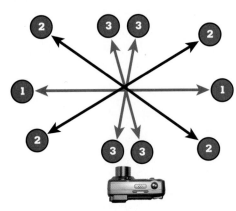

1. 1/2000 Second or Faster

2. 1/500–1/1000 Second

3. 1/250–1/500 Second

Figure 12.5—*To stop action, you need very fast shutter speeds if the subject is moving at a right angle to the camera, but slower shutter speeds when the subject is moving at an angle toward or away from the camera.*

→ *Need more information about setting shutter speeds? See "Using Shutter Priority Mode," **page 101**.*

→ *To learn about scenes, see **Chapter 5**, "Using Scenes."*

CANDIDS AND PORTRAITS

Generally, I switch to Aperture Priority to shoot portraits because I can keep the subject in sharp focus and blur out the background by selecting a wide aperture. However, you can shoot good portraits in Shutter Priority mode (see Figure 12.6): When possible, use a shutter speed fast enough to keep blinks from blurring the eyes or causing motion blur (generally 1/60 second or faster) and make sure the aperture is in the f/1.8–f/5.6 range. Increase your shutter speed as needed if the camera wants to set a narrower aperture (f/8, f/11, f/16, and so on).

If you're shooting a group of people at different distances from the camera, check your shots afterward. If some of them are out of focus, reduce your shutter speed as needed to narrow the aperture and get everyone in focus.

SPORTS AND ACTION

Sports and action photography are a couple of the best reasons to use shutter priority. Generally, I use 1/125 second to 1/500

second or faster for shots of children playing, athletes in action, or other types of motion.

1. 1/60 Second, f/2.2, ISO 400

2. 1/25 Second, f/4.5, ISO 400

3. Sharpest Focus

4. Acceptable Focus

5. Out-of-Focus Background

Figure 12.6—*Portraits taken in Shutter Priority mode.*

A slight amount of motion blur happens at 1/125 to 1/250 second, but it can enhance the action. Use slower shutter speeds, though, and you can get too much blur (see Figure 12.7).

WATER AND RAIN

Use too fast a shutter speed to shoot running water and it looks like ice (Figure 12.8). To make water look like water, use 1/250-second or slower shutter speeds (Figure 12.9).

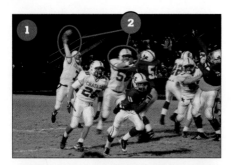

1. 1/125 Second, f/5.6, ISO 1600

2. Motion Blur

A

3. 1/40 Second, f/3.6, ISO 400

B

Figure 12.7—*Motion blur can enhance action (A) or be a distraction (B) if the shutter speed is too slow.*

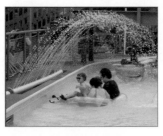

Figure 12.8—*1/800 sec-ond, f/5.5, ISO 400.*

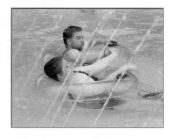

Figure 12.9—*1/200 second, f/5.5,ISO 200.*

ICE AND SNOW

To capture the beauty and fury of a snowstorm while the snow is falling, use a fairly slow shutter speed (1/60 to 1/125 second), as shown in Figure 12.10. However, if you want to catch the drip-drip-drip of a melting icicle, use a much faster shutter speed (see Figure 12.11).

1. Water Droplets

Figure 12.10—*1/60 second, f/3.2, ISO 80.*

Figure 12.11—*1/640 second, f/9.0, ISO 800.*

CHILDREN PLAYING

How fast a shutter speed do you need to catch children in action? It depends. If there's plenty of light, use a shutter speed up to 1/500 second or faster (see Figure 12.12). However, depending on what the kids are up to, you can get great shots at much slower shutter speeds as well (see Figure 12.13).

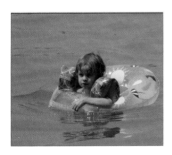

Figure 12.12—*1/640 second, f/5.6, ISO 200.*

Figure 12.13—*1/40 second, f/1.8, ISO 1600.*

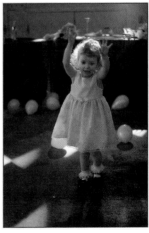

AMUSEMENT AND THEME PARKS

Stay all day at an amusement or theme park and you'll see opportunities for action when the sun is shining (see Figure 12.14). You also might catch a spectacular light show at closing time. Be sure to use a tripod or other fixed surface to hold your camera because you'll need to use slow shutter speeds or the Fireworks scene setting to get pictures like the one in Figure 12.15.

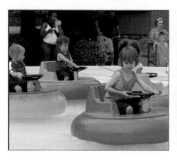

Figure 12.14—*1/250 second, f/11, ISO 400.*

Figure 12.15—*1/15 second, f/3.3, ISO 400.*

SELECTIVE BLUR

Not all motion blur is bad. Figures 12.16 and 12.17 illustrate how a bit of motion blur makes pictures of everyday life more interesting.

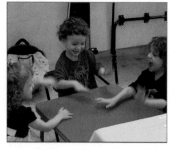

Figure 12.16—*1/13 second, f/3.2, ISO 400.*

Figure 12.17—*1/80 second, f/3.2, ISO 400.*

To get this kind of motion blur, use relatively slow shutter speeds (1/10 to 1/80 second) and a very steady hand, a tripod, monopod, or a camera with image stabilization to prevent camera shake.

PANNING

Using very fast shutter speeds to capture action can make your photos look like a game of statues. Panning, in which you move your camera parallel to the action at the same speed as the action, take the picture partway through the movement, and keep moving the camera afterward (see Figure 12.18) provides an exciting alternative to normal action photography by streaking the background (see Figures 12.19 and 12.20).

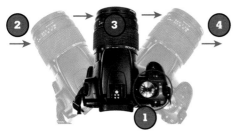

1. Select Shutter Priority (S, Tv) mode and 1/30 - to 1/125-second shutter speed.
2. Track the moving subject.
3. Take the picture as the subject crosses in front of you.
4. Keep the camera moving at the same speed as the subject before, during and after taking the picture.

Figure 12.18—*Move the camera to match the speed of the subject.*

Figure 12.19—*1/50 second, f/20, ISO 200.*

Figure 12.20—*Panning the camera downward to follow the slide using 1/60 second, f/3.2, ISO 400.*

CAPTURING PEAKS OF ACTION

If you need to capture a fast-moving subject when you can't use a fast shutter speed, shoot just before the subject reaches the end of its motion. Time the shot just right, and you can shoot action photos even when it seems impossible (and don't be afraid to try more than one). Figure 12.21 captures a carnival ride at sunset.

Figure 12.21—*Shooting the ride at the top of its swing stops action even with a fairly slow shutter speed (1/60 second).*

USING CONTINUOUS SHOOTING/BURST MODE

Most digital cameras can be set to fire a sequence of photos. This feature is called continuous shooting, burst mode, or similar terms.

Enable this feature, and you can shoot a series of pictures simply by holding down the shutter button. For best results, especially if the subject will be moving toward or away from you, switch your camera from single-shot focus to another mode such as AI servo or continuous focus (see Chapter 14 for details).

Use continuous shooting to help get better action shots, portraits, or other photos where timing is critical.

 CAUTION You cannot use your camera's onboard electronic flash in burst/continuous shooting mode, and most add-on flashes can't recharge fast enough to keep up either because you can take one or more shots per second in this mode.

USING ELECTRONIC FLASH

WHY YOU NEED THIS CHAPTER

Your camera's built-in flash is what I like to call a "necessary evil." Sometimes it's the only way to get a picture indoors or at night. However, if you use a higher ISO setting (see Chapter 10, "Improving Exposure"), or use image stabilization (see Chapter 15, "Using Zoom and Interchangeable Lenses") or a tripod (see Chapter 14, "Controlling What's in Focus"), you might not need to use your flash to get the photos you want.

However, sometimes flash is the best way to go. Whether your camera turns on the flash automatically or you decide to turn it on yourself but are not happy with the results, this chapter's the right place to turn for help.

Electronic flash can be swallowed up by a large auditorium or gymnasium (see Figure 13.1) but works well inside a typical home (see Figure 13.2). If you use a DSLR, you can get more natural-looking lighting by using an add-on flash with a bounce head (see Figure 13.3). Refer to Figure 13.17 for a typical example of an electronic flash with a bounce head.

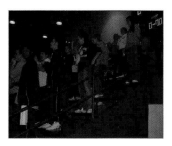

Figure 13.1—*Electronic flash produces poor results in a large area.*

Figure 13.2—*Electronic flash is better suited for smaller settings.*

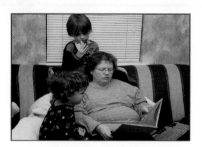

Figure 13.3—*An electronic flash with a bounce head produces softer, more natural results than direct flash.*

USING BUILT-IN FLASH

In full automatic mode, your camera will turn on its built-in flash in dim light outdoors or in most indoor lighting situations automatically. Understanding its limitations and learning when not to use flash will help you get better photos.

WHEN TO USE BUILT-IN FLASH

Use your camera's built-in flash to take pictures in the following conditions:

■ The light's too dim to get a good photo without motion blur or camera shake (see Figure 13.4).

■ The subject's no more than 10–15 feet away.

■ If you're shooting a group, everyone's at the same distance from the camera (see Figure 11.5). In the picture on the left, the people pictured are at different distances so you get different results. At the right, you see that the people pictured are the same distance from the camera.

Figure 13.4—*Motion blur and camera shake caused by 1-second exposure time (left). Bounced electronics flash stops blur (right).*

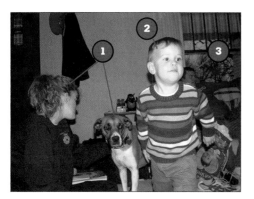

1. Just Right
(Properly Exposed)

2. Too Light
(Overexposed) and
Fuzzy (Out of Focus)

3. Too Dark
(Underexposed)

4. Same Distance,
Good Results

Figure 13.5—*For the best flash pictures, make sure your subjects are at the same distance from the camera—and make sure they're in focus.*

CONTROLLING BUILT-IN FLASH

If the flash doesn't turn on automatically, press the Flash button on the top or side of your camera (see Figures 13.6 through 13.8).

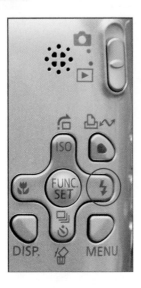

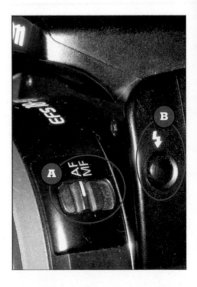

Figure 13.6—*A flash control button on a typical point-and-shoot camera (Canon).*

Figure 13.7—*Lens auto/manual focus control (A) and flash pop-up button (B) on a typical DSLR (Canon).*

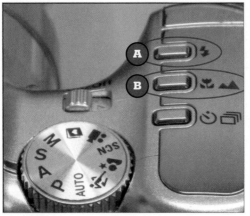

Figure 13.8— *Flash control (A) and focus control (B) buttons on a typical point-and-shoot camera (Kodak).*

With most point-and-shoot cameras, pressing the Flash button repeatedly will cycle through various flash settings, such as

 Red-eye reduction Auto flash

 Forced (fill) flash No flash

The icon for the current flash mode is usually displayed on your camera's main LCD display or on the monochrome LCD display near the shutter button.

WHY USE BUILT-IN FLASH?

Electronic flash stops action, so you avoid motion blur and camera shake in dim light (see Figure 13.9) and capture children at play (Figure 13.10). Electronic flash lights up the main subject to emphasize the focus of your shot (Figure 13.11). Using electronic flash also means you can use your default daylight or auto white balance and get more accurate colors.

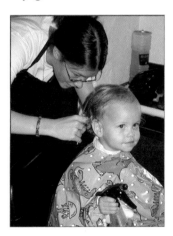

Figure 13.10—
Capture children at play.

Figure 13.9—*Avoid motion
blur and camera shake in
dim light.*

Figure 13.11—*Light up the
main subject and darken a
distracting background.*

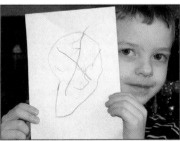

HOW TO USE BUILT-IN FLASH

Set your camera for full auto or Program mode, make sure your flash is on, focus on your main subject, and take the picture. Because built-in flash uses the same battery the camera uses, the flash requires several seconds to recharge before you can take another picture.

If you use Aperture Priority mode, use your widest aperture (lowest f-number) to ensure adequate light reaches your subject. If you use Shutter Priority mode, use a shutter speed of 1/60 second or faster to avoid ghosting (see Figure 13.12), especially in a brightly lit room.

Figure 13.12—*Using a 1/15-second shutter speed with electronic flash in a bright room, especially at ISO 400 or higher (or High ISO setting) can lead to ghosting.*

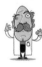

TIP To avoid running out of battery power, buy a spare battery for your camera and make sure it's fully charged. Or if you frequently take flash photos from a spot near an AC outlet, you might want to buy an AC adapter for your camera.

USING FILL FLASH

When you set the flash to fire on each picture, you are using fill flash (also called forced flash).

WHEN TO USE FILL FLASH

Use fill flash when your subject is in shadow or is backlit (see Figure 13.13) and you want both the subject and the background to be properly exposed in the photo (Figure 11.14).

Figure 13.13—*The backlit subject is too dark.*

Figure 13.14—*Fill flash keeps the background detail while bringing out the subject detail.*

WHY USE FILL FLASH?

By balancing background and foreground lighting (refer to Figure 13.14), you get photos that look more like the human eye sees subjects (the eye can compensate for big differences in lighting better than a camera without flash can).

Using fill flash to improve foreground lighting is also quicker than increasing exposure with the camera's exposure value (EV) adjustment menu (see Chapter 10 for details).

HOW TO USE FILL FLASH

To use fill flash with a point-and-shoot camera, use the camera's flash control button or menu to select forced (fill) flash. With a DSLR camera, push the flash button on the camera to pop up the onboard flash.

Focus on the subject, make sure the subject is within flash range (typically 10–15 feet), and take the picture.

BEFORE AND AFTER FILL FLASH

Figure 13.15 compares a backlit shot to a shot taken using fill flash.

Figure 13.15—*No fill flash (left) and with fill flash (right).*

USING ADD-ON FLASH

Built-in flash is convenient, but its slow recycling time and limited range mean it's not as useful in dim light situations as it could be. And, if you shoot with a wide-angle lens on a digital SLR, especially at close distances, you also need to watch out for the lens barrel or the lens shade casting a shadow across the bottom of your flash pictures (see Figure 13.16).

Figure 13.16—*Shooting extreme close-ups with built-in flash and a long-barreled wide-angle lens (A) can cause the lens or lens shade to cast a shadow across the bottom of the photo (B).*

If your camera has a hot shoe (see Figure 13.17), you can add an external flash unit and get more range and, with most models of add-on flash, the capability to tilt the flash head for a softer, less artificial-looking photo.

Some add-on flash units provide maximum ranges of up to more than 80 feet from the camera, compared to the 10–15 feet range of a built-in flash.

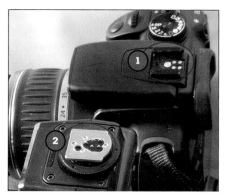

1. Hot Shoe on Camera

2. Matching Connections on Dedicated Electronic Flash

3. Tilt Head
4. Swivel Head
5. Secondary Flash Head
6. Diffuser

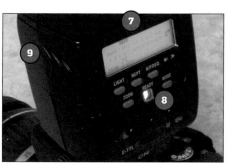

7. Control Panel

8. Ready Light

9. Battery Compartment

Figure 13.17—*Features of typical dedicated electronic flash units.*

HOW TO USE ADD-ON FLASH

Add-on flash units made specifically for your digital camera are usually referred to as *dedicated* flash units. These flashes are made by the camera vendor or third-party vendors. Note that dedicated flash units made for film cameras might not work properly (or at all) with digital cameras, and older nondedicated flash units could damage your camera.

Dedicated electronic flashes use multiple electrical contacts on the bottom of the flash shoe to carry exposure and other signals between the camera and the flash (refer to Figure 13.16). For best results, make sure the flash is set to TTL mode, which enables these connections.

Slide the flash into the camera's hot shoe and fasten it into place, and then turn on the flash. When the ready light on the rear of the flash is on (refer to Figure 13.17), you can take pictures. Most cameras indicate the flash is ready by displaying a lightning-bolt icon on the LCD display or in the viewfinder. Be sure to wait for the ready light or LCD flash ready icon to reappear before taking another photo.

USING BOUNCE, SWIVEL, AND DIFFUSER OPTIONS

Most add-on electronic flash units have a bounce head, and many also feature a swivel head and a diffuser that snaps over the flash head. A few flash units offer a second flash head that can be used to fill in shadows when the primary flash head is tilted or swiveled (refer to Figure 13.17).

WHEN TO USE BOUNCE, SWIVEL, AND DIFFUSER OPTIONS

Use the bounce head when you want to take flash pictures of people at different distances from the camera (see Figure 13.18) or to reduce harsh shadows (see Figure 13.19).

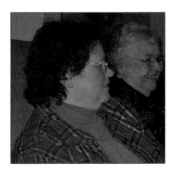

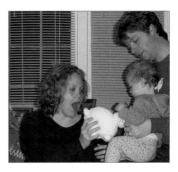

Figure 11.18—*The subject at right is farther from the camera and too dark.*

Figure 13.19—*The electronic flash casts shadows on the left side of subjects.*

Use the swivel head to bounce flash off a wall. Use the diffuser attachment if your wide-angle flash shots are dark in the corners (see Figure 13.20).

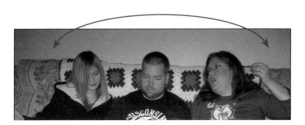

Figure 13.20—*The flash doesn't reach the corners of the picture.*

WHY USE BOUNCE, SWIVEL, AND DIFFUSER OPTIONS?

Using the bounce and swivel features enables you to create more natural-looking flash shots while still stopping action. Using the diffuser attachment prevents flash shots with wide-angle lenses from "hot-spotting" (having proper exposure in the center but dark edges).

HOW TO USE BOUNCE, SWIVEL, AND DIFFUSER OPTIONS

To use the bounce feature, tilt the head of the flash upward to about 45°. If you have a ceiling that is 10 feet high or shorter and is white or a light color, you might be able to take bounce

flash shots up to 15–20 feet away. You also can make or buy bounce head cards so you can use bounce flash if you are shooting in a room with high ceilings or outside.

To use the swivel feature, turn the flash head toward a nearby wall that is white or a light color (bouncing the flash off a colored wall makes the bounced light the same color as the wall). You also can tilt the head.

To use the diffuser, snap it to the front of the flash when you are using an 18mm or shorter lens (most DSLR cameras) or a 14mm or shorter lens (Olympus and other FourThirds System DSLR cameras).

Take your pictures after turning on the flash and waiting for the ready light to glow.

BEFORE AND AFTER PHOTOS (BOUNCE, SWIVEL, DIFFUSER)

Figures 13.21 and 13.22 compare a direct flash photo to a bounce flash photo. Note how the light is softer and more natural looking.

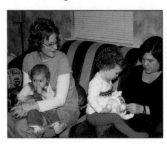

Figure 13.21—*Harsh shadows caused by direct flash.*

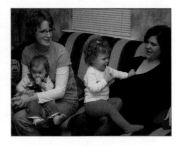

Figure 13.22—*Soft bounce flash is flattering to subjects and easy on the eyes.*

USING FLASH EXPOSURE COMPENSATION (EV)

Sometimes, flash photos can be too dark or too light. Some point-and-shoot, and most DSLR, cameras provide a flash exposure compensation or Flash EV adjustment option that enables you to adjust flash exposure. It works the same way as normal EV adjustment, but for flash photos only.

→ *See the section "Using EV Adjustment,"* **page 118**, *for details.*

WHEN TO USE FLASH EXPOSURE COMPENSATION

Use flash exposure compensation when flash pictures are too bright (overexposed). You also can try flash exposure compensation when flash pictures are too dark (underexposed), but it might not be as useful because flash pictures usually are too dark because you are shooting a subject beyond the effective range of the flash.

WHY USE FLASH EXPOSURE COMPENSATION?

Flash exposure compensation prevents subjects from being overexposed, and when you use fill flash, flash exposure compensation helps fill flash look more natural (refer to Figure 13.25).

HOW TO USE FLASH EXPOSURE COMPENSATION

Cameras with flash exposure compensation might feature a menu (see Figure 13.23) or a setting you can adjust while shooting (see Figure 13.24).

Figure 13.23—*The flash exposure compensation menu (DSLR) set to -1.3 EV.*

Figure 13.24—*Flash exposure compensation in shooting display (point-and-shoot) set to +1.0 EV.*

To reduce flash exposure, move the setting in the minus (–) direction. To increase flash exposure, move the setting in the plus (+) direction.

BEFORE AND AFTER FLASH EXPOSURE COMPENSATION

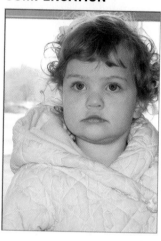

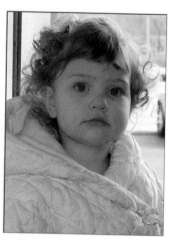

Figure 13.25—*No flash exposure compensation; flash overpowers the background.*

–1.0 flash exposure compensation preserves the backlighting "halo" effect.

CONTROLLING WHAT'S IN FOCUS

WHY YOU NEED THIS CHAPTER

If you want to create decent photos, it's essential to make sure your main subject is in focus. However, that isn't as easy as it sounds. For example, if you're shooting landscapes, you want everything (or almost everything) in the frame to be in sharp focus (see Figure 14.1). However, for portraits, you want to blur out the background (see Figure 14.2).

Figure 14.1—*Narrow (f/20) aperture helps keep this sunset in sharp focus.*

Figure 14.2—*Wide (f/5.6) aperture blurs the background for a great portrait.*

ISO HI With a simple digital point-and-shoot camera that offers only limited options, you might be able to accomplish the first objective by increasing the ISO setting so the camera uses

a smaller aperture (which increases the depth of field), and the second objective by selecting Portrait mode, which forces the camera to use a wide aperture (which reduces the depth of field).

However, if your camera offers the capability to select the aperture manually, adjust the ISO manually, or use manual focus, you have full control over what's in focus. By controlling focus, you help viewers see what part of the photo is most important. This chapter shows you how.

UNDERSTANDING DEPTH OF FIELD

What is depth of field? I could quote you technical explanations galore, but here's a simple one: Depth of field refers to how much in front of and behind the point of sharpest focus is also in acceptably sharp focus.

Three factors affect depth of field:

- **The aperture (f-stop) in use**—The wider the aperture, the shallower the depth of field (see Figure 14.3).

Figure 14.3—*f/6.3 aperture blurs the background (A), whereas f/22 aperture brings the background into sharper focus (B).*

- **The distance to the point of sharpest focus**—The closer you are to the point of sharpest focus, the shallower the depth of field. This is why you will often see parts of a macro (ultra close-up) photo out of focus (see Figure 14.4).

1. Out-of-Focus Background

2. Sharpest Focus

3. Acceptably Sharp Focus

4. Out-of-Focus Foreground

5. f/3.2 Aperture

Figure 14.4—*Notice that portions of this photo are out of focus.*

- **The focal length (zoom setting) of the lens**—The shorter the focal length (smaller zoom setting), the greater the depth of field. As the focal length increases, the depth of field decreases (see Figure 14.5).

Figure 14.5—*f/6.3, 2.5x zoom (A), and f/6.3, 6.4x zoom (B).*

A

B

USING FOCUS LOCK

Most digital cameras focus on the center of the viewfinder or LCD display; however, quite often the subject of the photo is not in the center. Fortunately, virtually every digital camera supports a feature called *Focus Lock*. Focus Lock (which also locks the exposure on most cameras) enables you to shoot an off-center subject and get a sharp and clear photo.

WHEN TO USE FOCUS LOCK

Use Focus Lock when you want to focus on a subject that's off center, or to prevent the camera from focusing on a distant background.

HOW TO USE FOCUS LOCK

Focus Lock works the same way as Exposure Lock (see Chapter 8, "Recipes for Better Event Pictures"):

1. Aim the camera toward what you want to be in focus; make sure the intended subject is in the center of the viewfinder or LCD display.
2. Press the shutter button down halfway and hold it.
3. Frame your picture the way you want it.
4. Press the shutter button down the rest of the way to take the picture.
5. If you move closer or farther away from the subject, or zoom your lens to recompose, repeat steps 1 through 4.

FOCUS LOCK PHOTOS

Figure 14.6 illustrates the difference between not using Focus Lock and using Focus Lock.

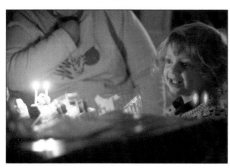

Figure 14.6—*(A) No Focus Lock—the focus is on the background. (B) Focus Lock—the focus is on the off-center subject.*

A

B

USING DIFFERENT AUTOFOCUS METHODS

Most digital cameras offer more than one way to use autofocus. Select the right method to help you get sharp pictures in different situations.

HOW TO USE FACE DETECTION

Face detection is a feature found in many recent digital cameras. It's designed to find faces turned toward the camera and focus on them, even if they're well away from the center of the picture. As you can see from Figure 14.7, face detection works automatically; just press the shutter button partway, and take the picture as soon as the face-detect frame highlights the face(s) you want in focus.

Use face detection when you are shooting photos of individual people or groups of people, especially in a casual environment such as a party or reunion.

Figure 14.7—*The face detect frame.*

HOW TO USE MULTIPLE AREA FOCUS SELECTION

Most newer digital cameras can select more than one area for focusing, as shown in Figure 14.8. When the focus frame changes color after you press the shutter button partway, the area inside the frame is in sharp focus. If the intended subject is not in the focus area, release the shutter button, re-aim the camera slightly, and press the shutter button partway down again.

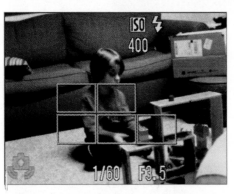

Figure 14.8—*Focus frames.*

USING USER-SELECTABLE FOCUSING ZONES/POINTS

If you are not satisfied with the results using multiple focusing zones, consider switching your focus method to the center or to a single area. The focus method setting is usually found in the shooting menu on most digital cameras; some DSLR cameras use a button to select automatic (multiple) or manual focus point selection (see Figure 14.9). Using manual focus

points, as in Figure 14.9, enables the user to select a focus point that matches the position of the subject, making it easier to focus on an off-center subject without needing to recompose the picture after using Focus Lock.

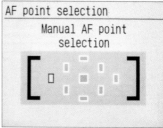

Figure 14.9—*(Left) Default focus zone setting on a Canon DSLR camera: The camera selects the focus zones to use based on the specific scene. (Right) Manual focus zone selection: The user selects any one of the focus zones.*

DIFFERENT AUTOFOCUS MODES

By default, most digital cameras use an autofocus mode that sets the focus when you press the shutter button partway. This is often referred to as One Shot or Single AF autofocus. This works well for subjects that are standing still or are moving across your field of view. However, if the subject is moving toward you or away from you, this focusing method can cause out-of-focus shots.

To keep moving subjects in focus, select autofocus modes that continuously focus on the subject in the middle of the viewfinder. These methods have names such as Servo AF or Continuous AF. When you use these modes, the normal focusing frames or dots in the display are shut off and the camera focuses on the middle of the frame. Remember to switch back to Single AF if you want to use focus lock or shoot off-center subjects. Some cameras offer a third mode that switches between single and continuous autofocus as needed.

CONTROLLING FOCUS WITH APERTURE SELECTIONS

Using wide apertures (f/5.6 and smaller numbers) enables you to use a technique called selective focus. Instead of most or all of the picture being in focus, only the area you select will be in focus.

On the other hand, using narrow apertures (f/11 and larger numbers) enables you to take pictures with a much deeper depth of field (more of the photo in focus). If you use apertures of f/16 and smaller, you can achieve an effect sometimes called "deep focus," in which all the photo is in sharp focus. Figures 14.10 and 14.11 compare the same scene shot with an f/2.8 and f/22 aperture.

Figure 14.10—By focusing on the rearview mirror frame and using a wide f/2.8 aperture, both the reflected scene and the objects across the street are thrown out of focus.

Figure 14.11—By focusing on the reflection in the rearview mirror and using a narrow f/22 aperture, the reflected scene and the objects across the street are very sharp, and even the rearview mirror frame is not completely out of focus.

WHEN TO USE WIDE APERTURES

Use wide apertures to blur out the background or to draw the eye to the main subject by blurring other parts of the photo. You can use wide apertures for portraits, nature photography, and macro photography, among other subjects.

WHEN TO USE NARROW APERTURES

Use narrow apertures when the entire photo is the subject, such as with landscapes or building shots, or when you are shooting a group of people at many different distances from the camera.

Keep in mind that the narrower the aperture, the less light the lens uses. As a consequence, you must use a slower shutter speed to get a good exposure. You might need to use a tripod or other steady surface for your camera.

SELECTING APERTURES

Use the aperture priority (A or Av) or Manual (M) settings on your camera and select the aperture (f-stop) you want to use (see Chapter 7, "Recipes for Better Daytime Pictures," for details). With most zoom lenses, the widest aperture changes as you zoom, so you might want to zoom first, and then select the aperture you want.

If you have a camera that uses scenes, select Portrait mode if you want to shoot with a wide aperture. To shoot with narrow apertures, see your camera manual for suggestions.

WIDE APERTURE (SELECTIVE FOCUS) PHOTOS

Figure 14.12 illustrates how using wide apertures can help isolate the main subject.

NARROW APERTURE (DEEP FOCUS) PHOTOS

Figure 14.13 illustrates how using smaller apertures are useful for making both foreground and background important parts of the photo.

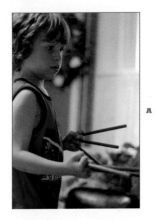

Figure 14.12—*(A) f/1.8, 1/80-second, ISO 1600, and (B) f/5.0, 1/125-second, ISO 400.*

Figure 14.13—*(A) f/18, 1/125-second, ISO 400, and (B) f/11, 1/125-second, ISO 200.*

USING DEPTH-OF-FIELD PREVIEW

Some DSLR cameras include a feature called depth-of-field preview. This feature enables you to see how the depth of field changes when a smaller aperture is used for shooting, either by you (in Aperture Priority or Manual modes) or by the camera (in Shutter Priority, Program, or Auto modes), compared to the normal widest-aperture view used to compose your photo.

WHEN TO USE DEPTH-OF-FIELD PREVIEW

Depth-of-field preview is most useful when you are shooting with narrow apertures (f/11 or higher f-numbers), because much more of the photo is in focus than is apparent when you are composing your picture.

HOW TO USE DEPTH-OF-FIELD PREVIEW

If your DSLR camera has a depth-of-field preview button (usually located near the interchangeable lens mount), select the shooting aperture, look through the viewfinder, frame the picture as desired, and press the preview button. The viewfinder gets darker, but objects closer to and farther away from what you focused on will appear sharper as well. Figure 14.14 simulates what you might see if you focus on a nearby object, select a small aperture, and use depth-of-field preview.

Figure 14.14—(A) The aperture wide open at f/5.6. (B) The depth-of-field pre-view button stops the lens down to f/18; note that the sign is now in focus.

USING MANUAL FOCUS

Autofocus doesn't always work, especially if there are objects such as wires, window glass, screens, or other obstructions in front of your intended subject (see Figure 14.15). DSLR cameras and a few point-and-shoot digital cameras include manual focus options.

Figure 14.15—
*Autofocus isn't
always the best
option.*

WHEN TO USE MANUAL FOCUS

Use manual focus when you have difficulty using autofocus because of obstructions, low light, or low contrast. If your camera "hunts" (changes focus frequently) when you are pointing the camera at a nonmoving subject, consider using manual focus if you can.

HOW TO USE MANUAL FOCUS

To use manual focus on a DSLR, find the autofocus/manual focus switch on the lens and move it to the MF (manual focus) setting (see Figure 14.16). After selecting manual focus, locate the focusing ring on the lens and turn it while looking through the viewfinder until the subject is in sharp focus (see Figure 14.17).

PREVENTING CAMERA SHAKE

If you want to use narrow apertures, especially in dim light or with ISO settings under 400, you need to use a tripod or place your camera on a steady surface. Although image stabilization/vibration reduction lenses or cameras (see Chapter 15, "Using Zoom and Interchangeable Lenses") can help you shoot with slower shutter speeds than with regular lenses, they cannot completely prevent camera shake, especially at shutter speeds of 1/8-second or slower.

WHEN TO USE A TRIPOD OR TRIPOD SUBSTITUTE

Use a tripod or other mounting device, such as a beanbag or clamp, when you will be using shutter speeds of 1/30 second

or longer with up to 4x zooms; for other lenses, see Chapter 10, "Improving Exposure," for recommendations.

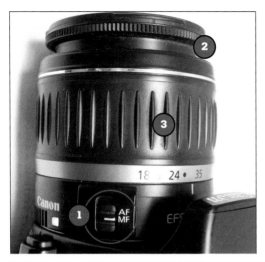

1. AF/MF Switch

2. Focusing Ring

3. Zoom Ring

Figure 14.16—
*Find the autofo-
cus/manual
focus switch,
and use the
focusing ring to
focus the shot.*

Figure 14.17—*The picture on the left is out of focus, but the
manual focus enables you to capture the image on the right.*

USING TRIPOD OR TRIPOD SUBSTITUTES

Attach a tripod or removable tripod mounting shoe to the threaded tripod socket hole at the bottom of the camera (see Figure 14.18). The shoe has a knob or tab that is turned to attach the tripod screw to the camera's tripod socket. If you are using a heavy lens that has its own tripod socket, use the lens's tripod socket instead of the camera's tripod socket.

Spread the legs of the tripod out as far as they will go. Adjust the legs to provide the height needed, and adjust the center shaft with the height adjustment knob or crank to fine-tune the height (see Figure 14.19).

Figure 14.18—
Preparing to attach a tripod mounting shoe to a DSLR.

1. Tilt Control

2. Loosen to Flip Camera into Vertical Position

3. Pan Control Knob

4. Height Adjustment Crank

5. Tripod Legs

Figure 14.19—*A typical tripod.*

USING A SELF TIMER

If you don't need to capture split-second action, use a self timer to help you get even steadier shots. A self timer generally provides a delay of up to 10 seconds between the time you press the shutter button and the moment the picture is taken. The self-timer function is indicated by a stopwatch-style icon on most digital cameras. You can also use a self-timer to provide time to get into the photo.

15

USING ZOOM AND INTERCHANGEABLE LENSES

WHY YOU NEED THIS CHAPTER

Have you ever wondered why your pictures are brighter when you don't zoom and get darker when you zoom? Are you trying to figure out why your attempts at portraits make your subjects look like gargoyles? Can't figure out why the digital zoom feature makes your high-megapixel pictures look like they were taken through a screen door? You've come to the right place.

Understanding how your camera's built-in or interchangeable zoom lenses work, and what your options are for interchangeable lenses on DSLR cameras, is essential if you want better pictures—and that process starts now.

Air shows and long zoom lenses are made for each other. I used the following settings in Figure 15.1:

- f/5.6

- 1/800 second

- ISO 200

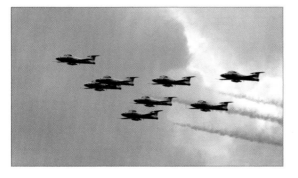

Figure 15.1—*A 220mm lens (12x equivalent) helps you get closer to the air show action.*

Fast (f/1.8 or wider) prime lenses for DSLR cameras make capturing special moments easy, even in dim light. I used the following settings in Figure 15.2:

- f/1.8

- 1/20 second

- ISO 1600

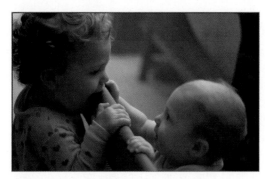

Figure 15.2—
A 50mm f/1.8 lens (3x equivalent) makes it easy to grab special moments, even in dim light.

ZOOM LENSES

Except for a few bargain-basement models, virtually every digital camera features a zoom lens. So, what's a zoom lens? A zoom lens can change its magnification at the touch or twist of a button (as in most point-and-shoot cameras) or at the twist of the zoom ring (as in DSLR cameras and a few high-end point-and-shoot cameras) which, in turn, moves lens elements inside the lens barrel. This type of zoom is known as an *optical zoom*. Figure 15.3 shows typical zoom controls on point-and-shoot and DSLR cameras.

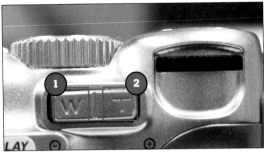

1. Wide Angle
 (Less Zoom)

2. Telephoto
 (More Zoom)

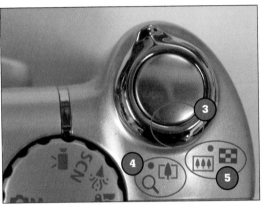

3. Zoom Selector

4. More Zoom

5. Less Zoom

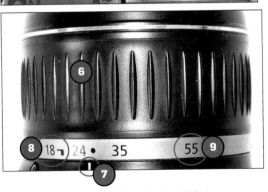

6. Zoom Ring

7. Zoom Selector

8. Minimum Zoom

9. Maximum Zoom

Figure 15.3—*Zoom controls on typical digital cameras.*

ZOOM RATIOS

Zoom lenses in point-and-shoot cameras are typically identified by their zoom ratios, such as 3x, 4x, 10x, and so on. This number refers to how much larger the subject appears at full zoom than at minimal zoom. Figure 15.4 compares shots taken of the same subject at 1x–12x zoom levels.

1. 12x

2. 8x

3. 6x

4. 4x

5. 2x

6. 1x

Figure 15.4—*The same subject at various zoom settings.*

 NOTE With a DSLR camera, you have to do a bit of math to figure out the zoom ratio of any lens. For example, to determine the zoom ratio of an 18–55mm lens, divide 55 by 18 to figure out the zoom ratio (it's just a tad over 3x).

However, if you have two or more lenses and you want to figure out the total zoom ratio they provide, divide the minimum and maximum focal lengths of the longer lens by the shortest focal length of your shortest lens. For example, if you have an 18–55mm lens and a 75–300mm lens, the 75–300mm lens provides a 4.17–16.67x zoom ratio compared to the 3x zoom ratio

of the 18–55mm lens. By performing this type of calculation, you can determine exactly how any new lens purchase affects your total zoom ratio.

OPTICAL VERSUS DIGITAL ZOOM

Many point-and-shoot digital cameras include a feature called *digital zoom* either in addition to or instead of an optical zoom. Sounds great, but digital zoom works by magnifying the pixels in an image. Figure 15.5 compares 12x digital and optical zoom photos. As you can see, optical zoom provides far better picture quality than digital zoom.

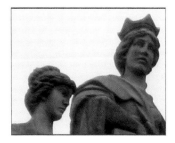 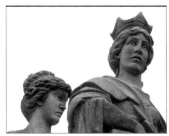

Figure 15.5—*12x digital zoom (left) and 12x optical zoom (right).*

How can you tell when your camera switches from optical to digital zoom? Some cameras display a magnification ratio when you switch to digital zoom (Figure 15.6), while others use a different-colored bar to indicate the change (see Figure 15.7).

Figure 15.6—
Digital zoom magnification showing a magnification ratio.

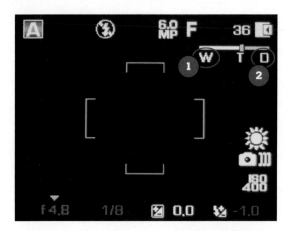

1. Zoom Slider

2. Digital Zoom Indicator

Figure 15.7—*The colored bar indicates the digital zoom.*

 TIP If you don't want to use digital zoom, you might be able to disable it through your camera's setup or shooting menus.

ZOOM LENSES WITH VARIABLE APERTURES

Most cameras and lenses (Kodak being a major exception) mark the maximum aperture (f-stop) on the front of the lens or the lens barrel. If you see a range of apertures marked on your lens, as in Figure 15.8, or listed in your camera or lens specifications, you have a variable aperture lens. This feature can cause problems when you're shooting in dim light or with flash.

Figure 15.8—*Maximum aperture range.*

As you zoom from 1x (widest view) to narrower views with a variable aperture zoom lens, the maximum aperture gets smaller, allowing less light for shooting. The result? You must use a slower shutter speed to provide correct exposure, or increase the ISO if you want to keep the same shutter speed. If you don't, you will get a dark photo (compare the pictures shown in Figure 15.9).

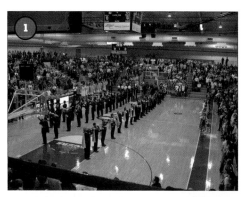

1. 8.2mm (1x), f/2.6,
1/125 Second, ISO 400

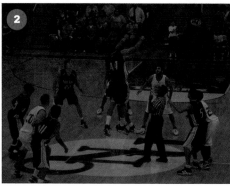

2. 31mm (3.78x), f/5.1,
1/125 Second, ISO 400

Figure 15.9—*f/5.1 allows about 25% of the light
compared to f/2.6.*

→ *To learn more about aperture settings and how different
numbers compare to each other, see the section "Using
Aperture Priority Mode," **page 103**.*

USING "NORMAL" ZOOM LENSES

Most low-end digital cameras have a 3x to 4x zoom lens. The
"kit" lens provided with most DSLR cameras as standard, usu-
ally an 18–55mm (Canon, Nikon, Sony) or 14–45mm
(Olympus Four Thirds), is also a 3x zoom.

3x–4x zooms provide moderate wide-angle to portrait telepho-
to coverage and are very useful for capturing everyday life.
Zoom back to 1x for dramatic group shots at close range (see
Figure 15.10). 2x zoom is a good choice for grabbing special

moments around you (Figure 15.11). Zoom out to 3x–4x for portraits (Figure 15.12).

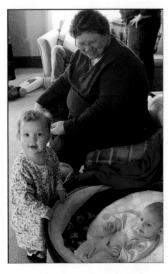

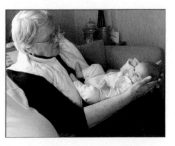

Figure 15.11—*2x zoom, f/5.0, 1/30 second, ISO 400.*

Figure 15.10—*1x zoom, f/2.8, 1/30 second, ISO 400.*

Figure 15.12—*3.8x zoom, f/5.0, 1/25 second, ISO 400.*

USING MEDIUM ZOOM LENSES

Many point-and-shoot digital cameras include zoom lenses with zoom ratios beyond 4x. Longer zooms enable you to get better photos of baptisms or other special events (Figure 15.13), isolate your main subject (Figure 15.14), or bring foreground and background closer to each other (Figure 15.15).

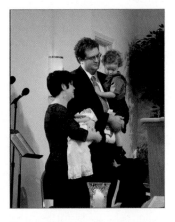

Figure 15.13—*4.8x zoom, f/3.6, 1/40 second, ISO 400.*

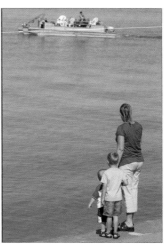

Figure 15.14—*5.3x zoom, f/8.0, 1/800 second, ISO 100.*

Figure 15.15—*100mm (5.6x zoom equivalent), f/8.0, 1/200 second, ISO 200.*

USING LONG ZOOM LENSES

Long zoom lenses (8x or longer) put you in the middle of the action, whether it's on the water (Figure 15.16), in the air (Figure 15.17), or on the field (Figure 15.18).

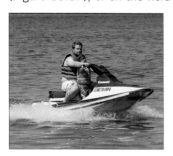

Figure 15.16—*220mm (12.2x zoom), f/10, 1/320 second, ISO 400.*

Figure 15.17—*300mm (16.7x zoom), f/8, 1/400 second, ISO 200.*

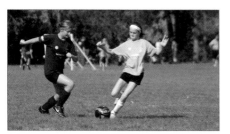

Figure 15.18—*300mm (16.7x zoom), f/8, 1/400 second, ISO 400.*

Keep in mind that as zoom lens ratios get larger, motion blur and camera shake can become an issue, especially at shutter speeds longer than 1/250 second.

SHOOTING PORTRAITS WITH ZOOM LENSES

You can take portraits with any lens, but what zoom ratio is the best? I recommend 3x–4x ratios, but what happens with longer or shorter ratios? Compare the zoom ratios used in Figure 15.19. The left photo was shot at 8x, while the right photo was shot at 1x. Note how the facial features are distorted by shooting at close range at 1x, but are much more pleasing when shooting from a longer distance at 8x.

1. 8x Zoom

2. 1x zoom at close distance distorts facial features.

Figure 15.19—*Want better portraits? Move back and use a 3x or longer zoom.*

USING FAST LENSES

Lenses with a maximum aperture of f/2.8 or wider are often called "fast" lenses because they allow more light than lenses with smaller maximum apertures (f/3.5–f/5.6), which in turn permits faster shutter speeds (Figure 15.20), shooting in lower light at the same ISO, or shooting in low light without a flash (Figure 15.21). Wide apertures also enable selective focus (Figure 15.22), which blurs the background to draw the eye to the main subject.

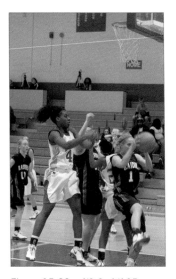

Figure 15.20—*f/2.8, 1/125 second, ISO 800.*

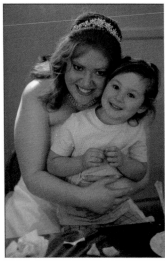

Figure 15.21—*f/1.8, 1/20 second, ISO 1600.*

Figure 15.22—*f/2.2, 1/80 second, ISO 1600.*

TIP If you have a DSLR made by Nikon or Canon, you can buy 50mm f/1.8 prime (non-zoom) autofocus lenses for around $100. These lenses make shooting in very dim light easy and are great lenses for portraits, providing about a 3x zoom compared to the 18mm (1x) setting on the standard zoom lens.

SHOOTING ULTRA CLOSE-UPS IN MACRO MODE

If you are having problems getting sharp pictures of extremely close (less than three feet or one meter) or extremely distant scenes with a point-and-shoot camera, you might need to change the camera's focusing mode.

🌷 Point-and-shoot digital cameras generally have at least two focusing zones: normal and macro.

🔺 Some cameras also include a third mode, variously known as Scenery, Distant, or Infinity AF.

To switch between modes, you might push a button on the camera or switch the control dial to the mode desired. Figures 15.23 and 15.24 compare close-up photos taken in normal and close-up (macro) modes.

Figure 15.23—*Normal focus setting.*

Figure 15.24—*Close-up (macro) focus setting.*

USING FILTERS

DSLR cameras, and a few point-and-shoot digital cameras, can use filters. A *filter* is an optical glass device used to alter the image seen by the camera. It can help by absorbing light (ND), changing the reflectivity of light (polarizer), adding a slight warming tone (Skylight), softening details (soft focus or fog), or protecting the front of the lens from damage (UV), to list just the most common types of filters. Most filters screw into

the front of the lens, but some wide aperture lenses used by professionals use filters that slip into the lens barrel. Figure 15.25 illustrates some of the most common types of filters discussed in the following sections.

1. Skylight 1B Filter (a Stronger Version of the Skylight 1A Filter)

2. UV Haze Filter

3. Circular Polarizer

4. Filter Sizes

Figure 15.25—*Typical Skylight 1B, UV, and polarizing filters used on digital cameras.*

WHEN TO USE UV AND SKYLIGHT FILTERS—AND WHY

UV filters were used on film cameras to help reduce UV haze effects on sunny, smoggy days, but are used primarily to protect the camera lens on DSLRs. Skylight filters have a slight pinkish tinge that adds a touch of warmth to your photos. The Skylight 1A version is more common, and the Skylight 1B version shown in Figure 15.25 has a slightly greater warming effect. Skylight filters also protect the front of the lens from damage.

WHEN TO USE A POLARIZING FILTER—AND WHY

Just as polarized sunglasses remove glare from reflective objects, darken blue clear skies, and provide more vivid colors, polarizing filters provide the same benefits for your pictures. Any camera with a threaded front lens mount (such as a DSLR camera) can use a polarizing filter, and tube adapters are available for some point-and-shoot cameras with retractable lenses.

 TIP To determine what size filter a particular lens uses, look for a marking like this one on the front ring or side of the lens barrel: Ø, followed by a number. For example, Ø55 indicates 55mm filter; Ø58 indicates 58mm filter, and so on.

Almost all digital cameras use circular polarizing filters (the name refers to the type of polarizing material used). The older linear polarizing filters interfere with modern autofocus methods and should not be used on autofocus cameras.

Use a polarizing filter outdoors on sunny days; use it indoors only if you are shooting photos of items in glass cases (it can remove reflections from the glass). Polarizing filters create more vivid colors in your photos by removing reflections from glass, leaves, and other shiny objects, and by darkening blue skies.

How to Use a Polarizing Filter

To attach a polarizing filter, screw it into the screw threads at the front of the lens or tube adapter barrel. If you are using a protective filter, such as UV or Sky/Skylight 1A/1B filter, remove it first. Aim the camera at your subject and revolve the front ring on the filter to adjust the polarizing effect. Take the picture when you are satisfied. To see the effect on a point-and-shoot camera, you must use the LCD display or electronic viewfinder, not the optical viewfinder.

Before and After Polarizing Filter

Polarizers intensify blue skies (compare Figures 15.26 and 15.27) and wipe out reflections on objects such as leaves and windows. (compare Figures 15.28 and 15.29).

Figure 15.26—*Washed-out blue sky without polarizer.*

Figure 15.27—*Intense blue sky with Polarizer.*

Figure 15.28—*Car windows and hood reflect sky.*

Figure 15.29—*Polarizer wipes away reflections.*

WHEN TO USE NEUTRAL DENSITY (ND) FILTERS— AND WHY

Neutral Density (ND) filters absorb light, enabling you to shoot with wide apertures or use slow shutter speeds even on a sunny day. ND filters are a uniform gray color and are available in various strengths. The most common types include ND2/ND0.3 (transmits 50% of light), ND4/ND0.6 (transmits 25% of light), and ND8/ND0.9 (transmits 12.5% of light). The camera will automatically adjust the exposure for you.

ADAPTING FILTERS TO YOUR POINT-AND-SHOOT CAMERA

If you have a point-and-shoot digital camera with a lens barrel that does not collapse completely, you might be able to purchase an adapter to enable your camera to use filters. The adapter is a metal tube that fits over the lens barrel and is threaded at one end to accept filters.

CAUTION Most filter adapters cut off the corners of the photo when the lens is zoomed to a wide angle. If you really want to use filters, I recommend purchasing a DSLR camera.

USING ANTI-SHAKE TECHNOLOGIES

Anti-shake technologies, usually referred to as image stabilization (IS) or vibration reduction (VR), are becoming increasingly popular in both digital point-and-shoot cameras and DSLR cameras. IS/VR technologies can be built in to the camera body (point-and-shoot cameras and some Olympus and Sony DSLRs) or built in to some interchangeable lenses (some lenses for Canon and Nikon DSLRs). IS/VR technologies built in to the camera body are enabled or disabled through menu settings, whereas IS/VR technologies built in to the camera lens use a selector switch on the lens (see Figure 15.30).

Anti-shake technologies enable you to shoot with slower shutter speeds and get sharp results. Figure 15.31 compares pictures taken at 1/15 second with and without IS/VR. Note that most vendors use the term image stabilization (IS), but Nikon refers to this technology as vibration reduction (VR).

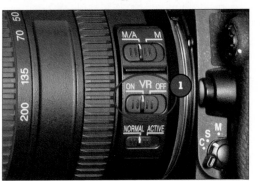

1. VR Selector Switch

Figure 15.30—*The IS/VR option on this Nikon zoom lens is enabled. (Photo © Jay Townsend/Primal Design Studio, LLC, 2009.)*

1. Fuzzy Details

2. Anti-shake Technology Makes Details Sharper

Figure 15.31—*A 1/15-second photo without IS/VR (left) compared with the same subject using IS/VR (right). (Photo © Jay Townsend/Primal Design Studio, LLC, 2009.)*

FREE Online Edition

Your purchase of **The Shot Doctor: The Amateur's Guide to Taking Great Digital Photos** includes access to a free online edition for 45 days through the Safari Books Online subscription service. Nearly every Que book is available online through Safari Books Online, along with over 5,000 other technical books and videos from publishers such as Cisco Press, Addison-Wesley Professional , Exam Cram, IBM Press, O'Reilly, Prentice Hall, Que, and Sams.

SAFARI BOOKS ONLINE allows you to search for a specific answer, cut and paste code, download chapters, and stay current with emerging technologies.

Activate your FREE Online Edition at www.informit.com/safarifree

STEP 1: Enter the coupon code: AAMYZAA.

STEP 2: New Safari users, complete the brief registration form. Safari subscribers, just login.

If you have difficulty registering on Safari or accessing the online edition, please e-mail customer-service@safaribooksonline.com